LYMINGTON

THROUGH TIME

Jude James &
Roland Stott

AMBERLEY PUBLISHING

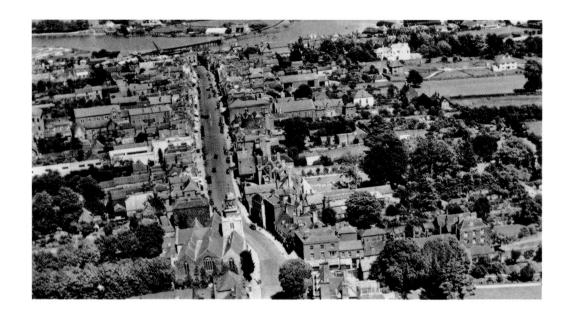

Acknowledgements

The authors would like to thank Steve Marshall, director of the St Barbe Museum and Art Gallery, for his wholehearted support for this publication. A member of his staff, Lianne Warner, has our special gratitude for helping to sort out illustrations and scan them. Chris Hobby, vice-chairman of the Milford-on-Sea Historical Record Society, generously helped by supplying a number of illustrations not available elsewhere for which we are indebted and we express our thanks to him. We also thank the Berthon Boat Co. Ltd, for permission to use the illustration of the yacht launching.

All proceeds of this book are to go towards supporting the St Barbe Museum in fulfilling its valuable cultural role to the whole community.

First published 2012

Amberley Publishing Plc
The Hill, Stroud
Gloucestershire, GL5 4EP

www.amberley-books.com

Copyright © Jude James & Roland Stott, 2012

The right of Jude James & Roland Stott to be identified as the Authors of this work has been asserted in accordance with the Copyrights, Designs and Patents Act 1988.

ISBN 978 1 4456 0954 6

British Library Cataloguing in Publication Data.
A catalogue record for this book is available from the British Library.

Typeset in 9.5pt on 12pt Celeste.
Typesetting by Amberley Publishing.
Printed in the UK.

Introduction

An Iron Age lowland hillfort known as Buckland Rings survives as a reminder that prehistoric people had settled in the area long before recorded history. However, it cannot be demonstrated that there is a direct connection with the market town of Lymington. This developed on the site of a small agriculture community recorded in Domesday Book and its formal creation was due to the grant of a charter by the lord of the manor, William de Redvers, 5th Duke of Devon. The terms of this charter, and the three that followed, ensured certain beneficial rights were bestowed on the residents, some of whom became burgesses. These included the right to hold markets and fairs and rights to levy harbour dues on visiting ships.

It may plausibly be conjectured that a small maritime settlement developed on the western bank of the Lymington River, about one mile upstream from the Solent. This facilitated the growth of a small port. The burgesses formed a corporation which had responsibility for maintaining the quay even before it was incorporated into the borough in 1405. In the centuries that followed, maritime trade fluctuated though always the most significant element was coastwise trade and links with the Isle of Wight.

The grant of the market was of immense commercial importance and it was always held on Saturdays. It served the villages of the whole of the southern New Forest. Fairs were also important and two were established, the first and most important was held on 'the eve, the day and the morrow of St Matthew the Apostle' (20-22 September annually), and the second was in May.

The charters enshrined the form of government for the borough and this was always based on appointed or elected burgesses working under the general jurisdiction of the manorial court of Lymington. This arrangement divided the manor into two sections, one known as 'Old Lymington', and the borough which was called 'New Lymington'. These

administrative distinctions persisted until abolished by the Municipal Corporation Act of 1835. In 1889 the whole ecclesiastical parish was incorporated into an expanded borough. This remained the situation until 1932 when a major expansion of the borough took place. Then, under Local Government reorganisation in 1974, the whole borough was absorbed into the New Forest District Council and Lymington joined with Pennington to form a town council.

From the reign of Elizabeth I the borough was required to send two members to parliament, a situation which was maintained until the Second Reform Act of 1867 when the borough's representation was reduced to a single member. The Third Reform Act (1884) took even this right away and Lymington was absorbed into a wider parliamentary constituency.

Probably, economically, the most important single activity was the industry that produced salt from the evaporation of sea water, which developed from early medieval times, though its origins go far back beyond that. The manufacture of salt was a summer activity which, depending on weather conditions, lasted from one to four months, but in that frenetic time produced sufficient wealth to underpin much of the town's commercial life. Although it cannot be quantified, smuggling from the eighteenth century became an important source of illicit revenue and led to a number of clashes between the smugglers and the authorities.

Lymington had a single parish church, dedicated to St Thomas the Apostle, which for hundreds of years was served by the Augustinian canons of Christchurch Priory. Following the Reformation that connection was broken and it became subsidiary to the parish church of Boldre and was not created a vicarage in its own right until 1867.

Because of the availability of illustrations, this book looks mainly at the period from about 1750 to the present day, but by so doing records a time of great change, which saw the town develop the distinctive character that makes it such a charming town for the resident and visitor today.

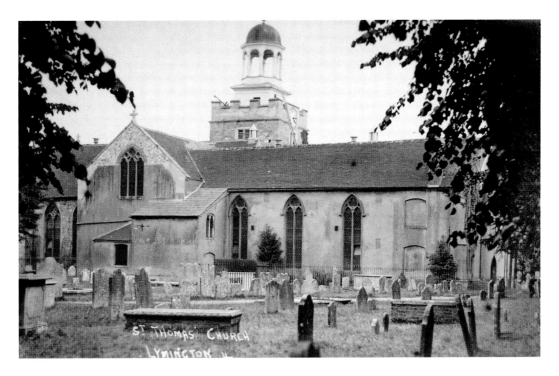

St Thomas Church – The North Side

The view of the church from the graveyard was changed forever when the Church Hall and associated buildings were constructed in 1981. The design was produced by the renowned local architect Roger Pinckney. He used materials, stone and red-brown clay tiles, to sympathetically blend with the fabric of the church. Only the church tower and its cupola now remain visible. The work was entirely financed from the sale of church land, lying a little to the north east, on which had been built the Parish Hall in 1926.

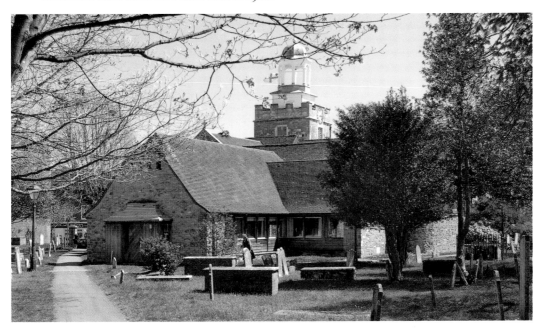

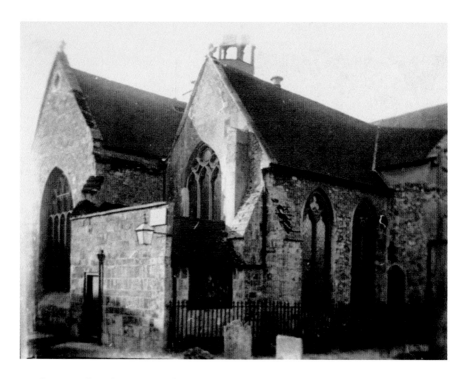

St Thomas Church – East End

The clergy vestry was once an extension to the Courtenay Chapel. It had been added in 1792 and required making a doorway through the chapel wall and defacing the fine Decorated period window. A desire to remedy this situation was agreed and a faculty to do so was obtained from the diocese in 1927. The sum required to carry out the work, including the building of a replacement vestry, came to £750, which had to be raised by public subscription. The work was completed in 1931, with the window restored and the Courtenay Chapel brought back into full liturgical use.

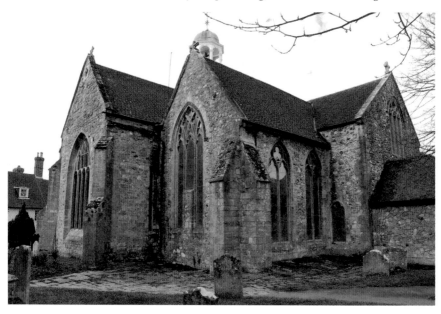

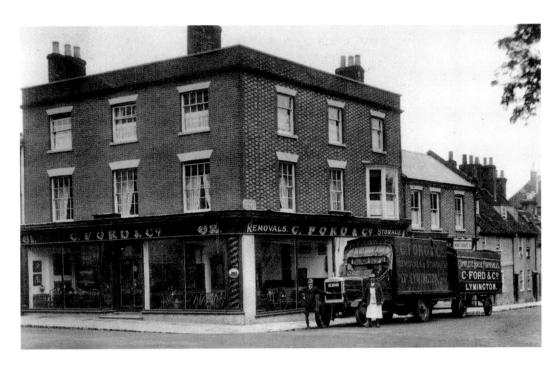

Numbers 61–62 High Street

This substantial brick edifice seems an appropriately bold terminal for the High Street. The building appears to have been erected in Regency times, retaining the basic classical motifs including an all-embracing parapet. It started life as a grocery business run by Richard Gibbs, a master tea dealer, in the 1840s–50s. It then passed into the hands of Henry Lamble who continued the grocery business into the late 1890s. The premises were sold to Charles Ford & Co., furnishers and removals, in 1905 who added it to their already established business situated almost opposite in St Thomas Street. Ford's relinquished this property in 1992.

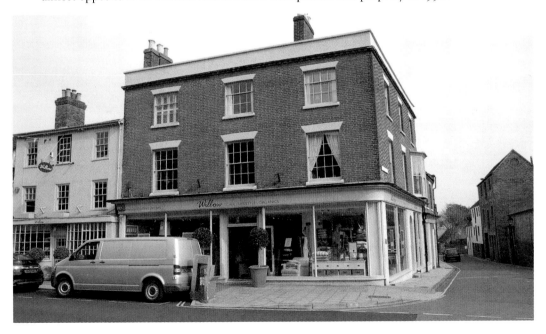

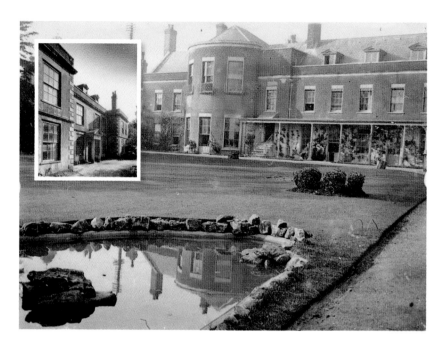

Home Mead (or Holme Mead)

This was one of several substantial houses built on the south side of the High Street. It possessed extensive grounds, part of which can be seen in the photograph. The inset picture shows the front facing the High Street. During the First World War it played a significant role as a hospital and convalescent home for wounded soldiers. It formed, in effect, an annexe of the large military hospital in Brockenhurst. Following the war it suffered a chequered history including becoming a furnisher's storehouse and was eventually sold to the post office who demolished the house and in 1960 built the present post office.

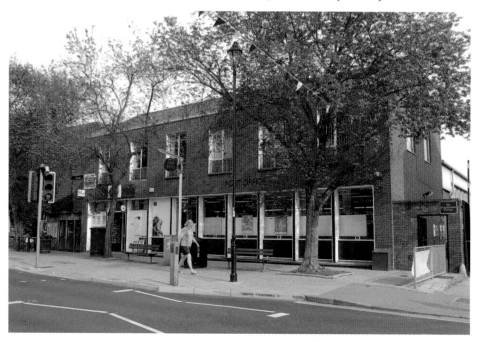

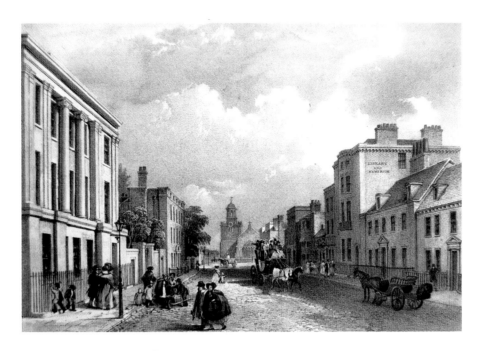

Grosvenor House, 52 High Street

The house on the left in the coloured print was built as a private residence around 1830 by James Monro who became mayor of Lymington in 1831. The engraving by Benjamin Ferrey is dated 1832, it clearly reveals the Grecian style of the façade with its two huge Ionic columns. In the mid-nineteenth century it became a private boarding school before reverting to private use. Subsequently, it was occupied by a succession of doctors. The house became vacant in the 1970s and was threatened with demolition but after protests it was agreed by the planning authority that the façade should be preserved though the rest of building was gutted to be transformed into commercial and retail premises.

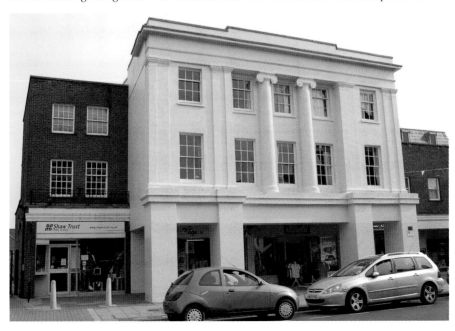

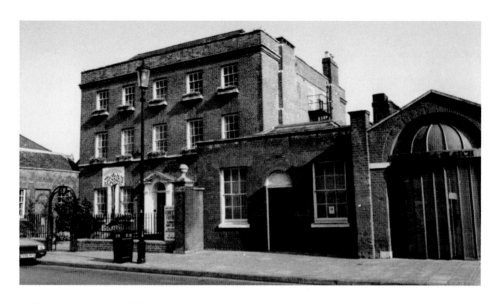

Bellevue House, 48 High Street

This is one of the grandest brick-built houses to adorn the south side of the High Street. It exemplifies Georgian architecture in being perfectly symmetrical. The whole three-storey façade is constructed of header bricks. Built in 1765 it remains little changed. The first owner and resident was J. Hackman, a Lymington doctor, who was succeeded by various notable 'Lymingtonians'. On 25 March, 1828 it came into the hands of the Lymington banker and saltern owner, Charles St Barbe, and remained with that family until 1854 when it was sold to a Mrs D. Solly. Around 1860 it was taken over by the Noake sisters who transformed it into a leading and successful private boarding school for young ladies. The grounds at the back, overlooking the Solent, provided a lovely play area for the pupils. The school closed in 1886, shortly after the death of Frances Louisa Noake, and the house returned to residential occupation, becoming the home of Dr Kay. After his death it was purchased by Moore & Blatch (now Moore Blatch), a firm of solicitors who remain in occupation.

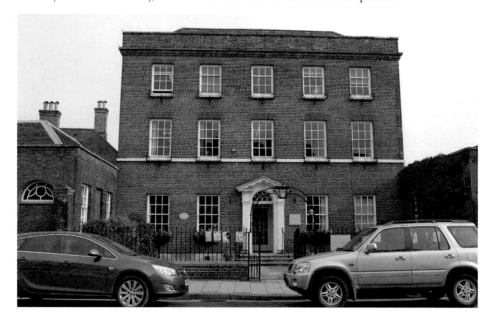

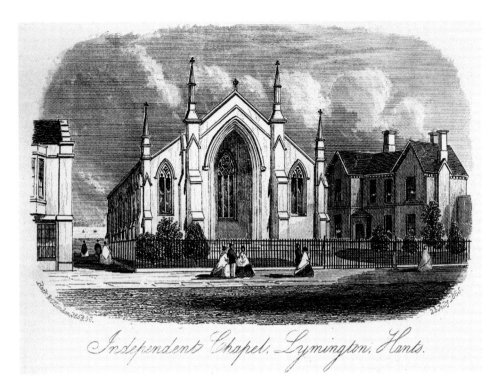

Independents Chapel, Lymington, Hants.

United Reformed Church

The Independents (Presbyterians) founded a church in Lymington in about 1672. The first place of worship was a chapel in St Thomas Street, but as the congregation expanded there was a need to find another site, on which to erect a larger church with an adjoining manse, a school and its own burial ground. The congregation was to play an important role in Lymington and the wife of one renowned minister, David Everard Ford, established a popular boarding school. The new church in the Decorated Gothic style is built of red brick but the north façade uses attractive yellow-buff bricks, which gives it a light appearance. The Independents were also known as Congregationalists and in the early 1970s the church was reorganised as the United Reformed Church (URC).

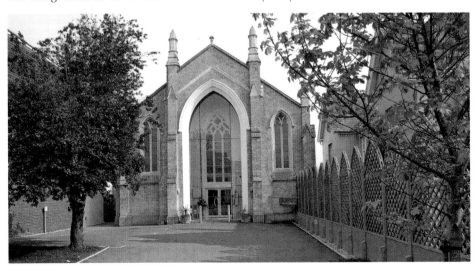

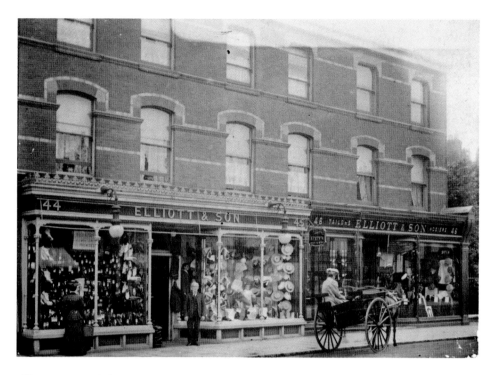

Elliotts 44–46 High Street

First established on the opposite side of the High Street in 1873, the firm moved to these larger premises in 1890 and merged what formerly had been three separate shops into a single emporium which has remained until the present day. Like many of the family businesses founded in the town in the nineteenth century, it underwent a sometimes chequered history that threatened its existence, but survived these vicissitudes so that it is now the oldest family business still successfully functioning. George Elliott, the founder, stands in the doorway of his shop.

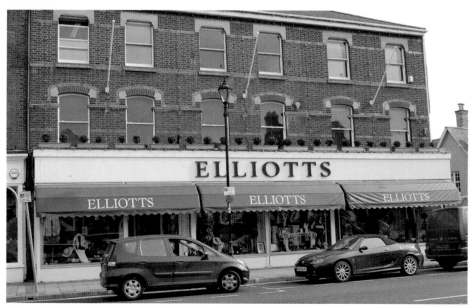

High Street, Numbers 40–42

This represents a total transformation: the seventeenth-century buildings with a single bow-fronted shop proved to be wholly inadequate to serve the needs of the burgeoning nineteenth-century market town. So in the mid-1800s they were swept away and replaced by a speculatively built red brick block, which so dominated the scene that it was derisively known at the time as 'Gibraltar' – others thought the sobriquet came from the fact that it was 'never taken' implying it was difficult to rent. Eventually, Nos. 41–2 were provided with a large shop front, enhanced with decorative wrought iron scrolls, which is preserved to the present day. Note the architectural similarity with the shop shown on page 7

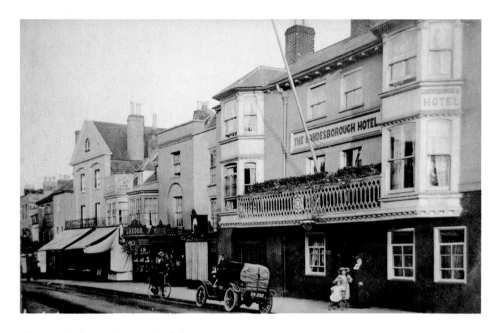

The Londesborough Hotel, High Street

Although superficially little changed it had ceased to be a hotel around 1965, though a bar at the rear continued for several more years. The ground floor on the High Street was transformed into shops. The earliest and long-established name for the establishment was the Nag's Head but in 1884 after it was patronised by the Earl of Londesborough the supposedly more elegant and certainly more aristocratic name of Londesborough was bestowed upon the posting house. In its early days it owned stables and fields to the rear for the accommodation of horses and it was from here that the 'Independent' coach departed each weekday at 5 a.m.

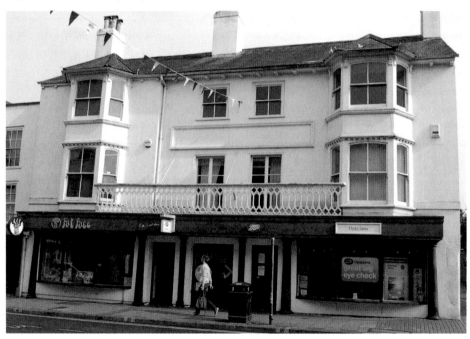

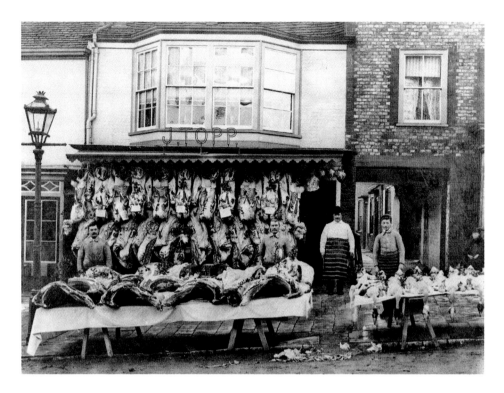

Topp's the Butcher

A vegetarian's nightmare! John Topp, with three assistants, stands proudly outside his shop, No. 20 High Street, showing a huge range of meat. Hanging in front of the shop is a display of mutton and lamb. Beef carcasses line the table in front while, to the right, is a display of poultry. This seems to have been a widely adopted practice by butchers around the turn of the nineteenth and twentieth centuries. The shop, now a restaurant, seems much more genteel, while the alley to the right leading to Topp's Yard is retained. The attractive first floor bow window seems virtually unchanged. An original gas street light with a fish-tail burner is clearly seen to the left.

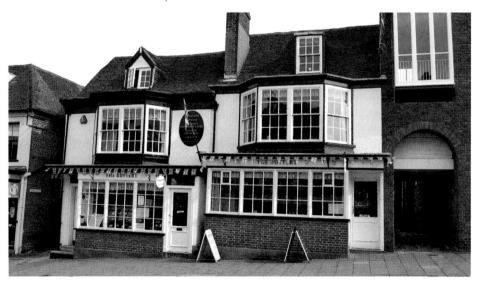

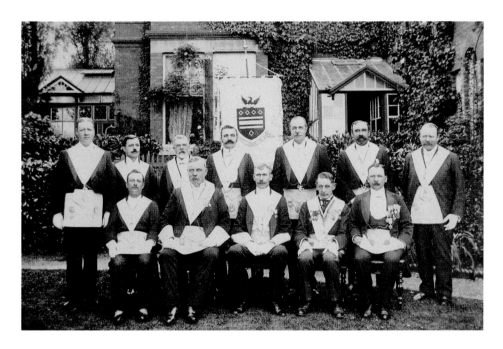

The Masonic Hall

The history of Freemasonry in Lymington is somewhat chequered. The first lodge was formed in the town in 1764 and its first meetings were held in the Crown Inn, later renamed the Anchor & Hope. These later transferred to the Nags Head (subsequently the Londesborough) in the High Street. It appears that membership of the masons faltered for a number of years until it was revived with the formation of a new lodge in 1814, but that too succumbed due to insufficient support. It was again revitalised but never established a firm footing until 1874 from which time their fortunes improved sufficiently to enable the purchase of land at 10 High Street, formerly the home of the Albion Hotel, on which they were able to build a substantial brick hall, lying back from the street. It was opened in May 1927 and remains in regular use. The Freemasons' emblem is clearly seen in the pediment.

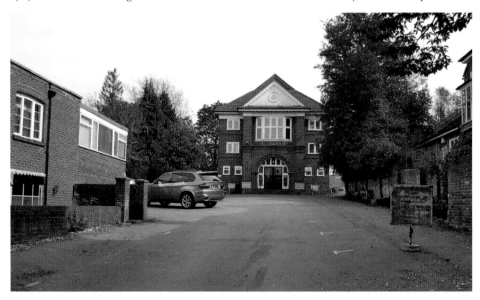

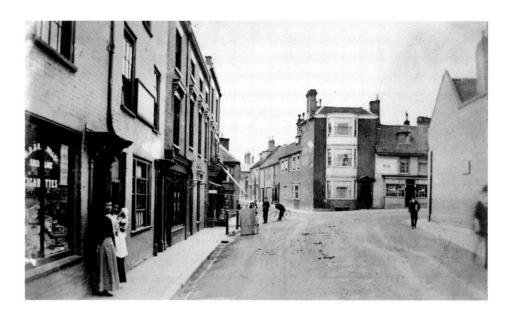

Number 1 High Street

This rather splendid Georgian house with its central bay extending to the full three-storey height of the building stands prominently at the junction of Captains' Row and the lower end of the High Street. It is unlikely that all these High Street properties were built as retail outlets but that was to become the destiny of most of them by the mid-nineteenth century, a use which persists to the present day. However, an early owner of this house was a physician and surgeon, Nicholas Adams, who had moved from Basingstoke to set up his practice here. After about thirty years he was succeeded by his son. In politics he was a radical and supported that party at the time of the Reform Act election in 1832. The property next door (No. 2) appears to belong to the early eighteenth century, though subsequently somewhat altered.

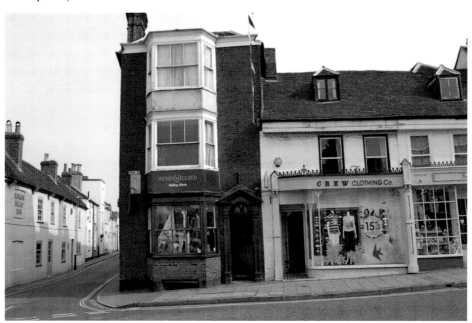

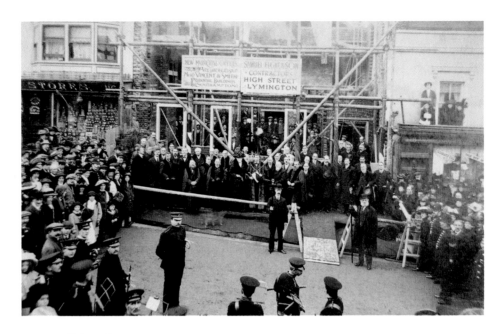

Town Hall & Earley Court

The picture shows the ceremonial occasion when Mrs Ellen Hewitt laid the foundation stone for the new town hall on 12 February 1913. This hall only functioned for fifty-two years, proving ultimately too limited in space to accommodate the increased levels of administration caused by the expansion of the borough and exacerbated by the extra responsibilities thrust upon local government following the Second World War. The rather grand town hall building was then demolished to be replaced in the late 1960s by Earley Court, a small shopping precinct named in honour of Mrs Martha Earley, sister of Ellen Hewitt, who had donated the properties, Nos. 117 and 118, to the corporation as a site for the town hall.

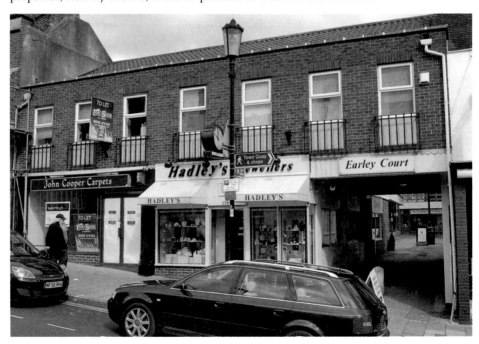

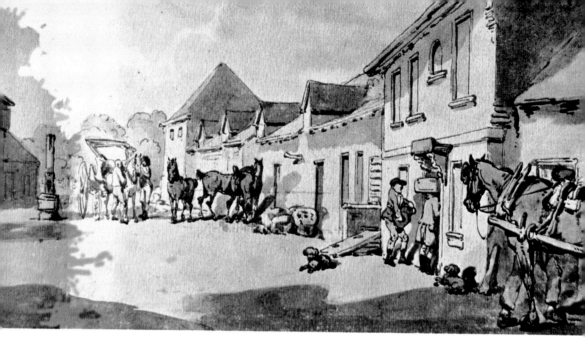

The Angel Yard

The Angel is perhaps the oldest inn in Lymington. In the eighteenth century it became a posting inn of major importance and was visited in 1785 by the artist Thomas Rowlandson, during his 'tour in a post-chaise', accompanied by his friend Wigstead. Among his many drawings in and around Lymington was this view of the Angel Yard showing a hive of activity. It is known that at this date there was stabling for at least twenty-three horses, plus harness room, accommodation for 'ostlers and sheds for coaches and carriages. The yard today has become a little commercial enclave with a number of small shops, some contained in the buildings that Rowlandson would have known. The Angel Inn still thrives and has a small beer garden projecting into the yard.

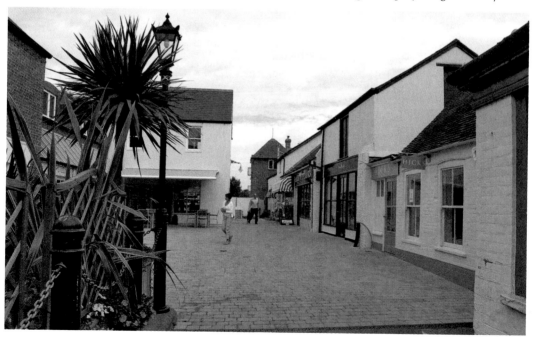

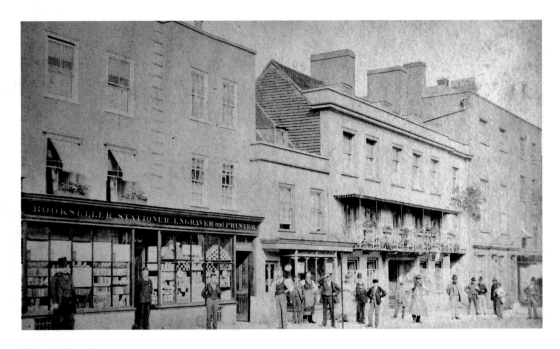

Kings of Lymington

The King family had run a bookselling and printing business in Yeovil since 1735, but in 1805, Charles King, a member of the family, decided to establish a business in Lymington. He was joined in 1817 by his nephew, Richard, who became a successful and prominent businessman who was to be elected seven times mayor of the Borough. He moved his shop to more spacious premises at 105-106 High Street where the family was to continue trading until 1988. Following the death of Mary King in 1987, the last of the direct line of the family to be fully engaged in running the shop, it was sold to four members of the staff. It had claimed to be the oldest continuously trading family bookselling business in England. The shop is currently owned by Waterstone's.

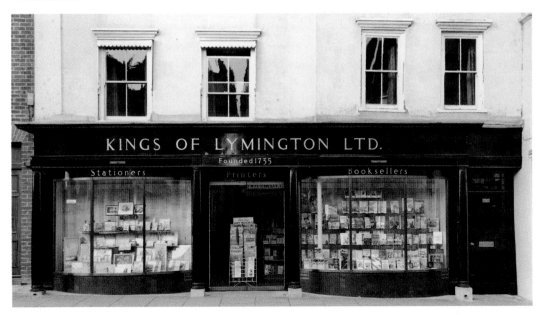

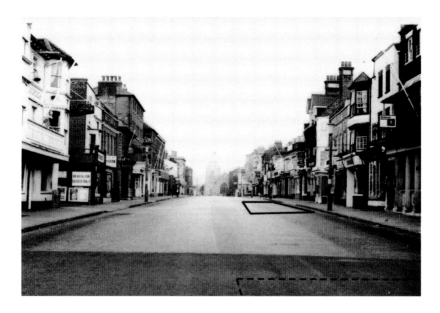

The Earlier Town Halls

Lymington's earlier town halls had occupied sites on the south side of the street, but in 1684 the town's burgesses authorised the construction of a purpose built town hall which was to stand in the highway, in the position marked by the black outline. The corporation's hall occupied the upper room, supported on stone columns; the ground floor providing covered space for a corn market. By 1710 it was considered to be no longer suitable and Paul Burrard, MP, financed the construction of a larger and grander town hall to stand approximately where the photographer stood to take this photograph. The corner of this building is marked by the broken lines. The 'old' hall was leased to Fulford's Grammar School which continued to occupy the site until demolished in 1782. Some of its columns are now in Woodside Gardens. The replacement town hall, supported on arches rather than columns, remained in use until it was considered an obstruction in the busy highway and was demolished in 1858. The Borough Council (as it had become 1835) was then left without a permanent home until 1913.

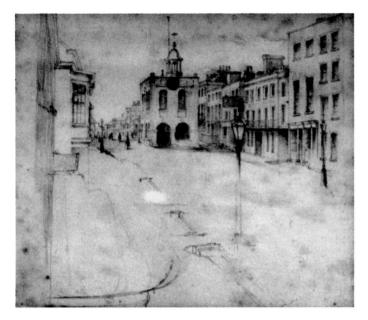

The Later Town Halls

The drawing above shows the second town hall to be built in the highway in 1710. It was demolished in 1858 leaving the Council without a permanent home. Council meetings were then held in the Assembly Rooms of the Angel Inn, which is the tall building on the right in the drawing. Initially it was leased for twenty-one years at an annual rent of £25, but continued in use for almost sixty years. As described on page 18 Mrs Martha Earley bequeathed to the corporation two properties in the High Street to create a permanent town hall which was opened in 1913. By the 1950s it was proving too cramped to accommodate the increasing workload of the council and in 1962 it was agreed to build a new town hall in Avenue Road. This was formally opened by Her Majesty Queen Elizabeth II on 15 July 1966 (*see* page 23).

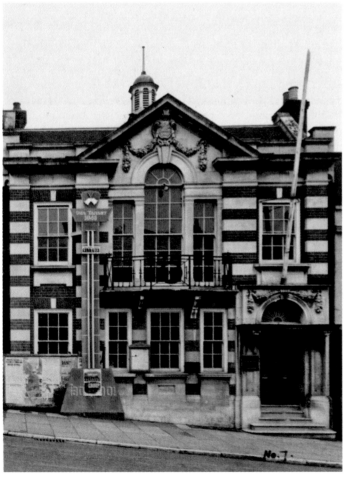

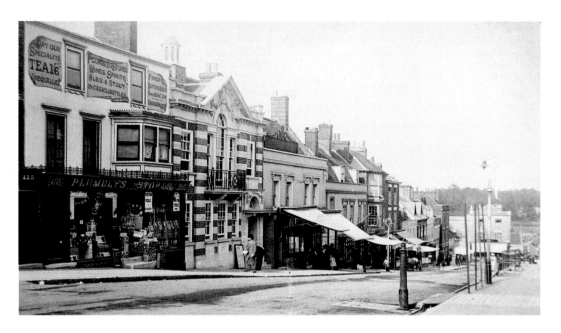

The New Town Hall

The town hall that had served the Borough of Lymington since its opening in 1913 proved inadequate for modern needs. It then was recognised that a more radical solution to the problems was required and in April 1962 a decision, not without some spirited opposition, was taken to build a more capacious new hall on a pristine site in Avenue Road. This hall was built in 1963-4 and was ready for the official opening by Her Majesty the Queen on 15 July 1966. The Borough Council came to an end in 1974 with Local Government Reorganisation when Lymington was absorbed into the New Forest District Council and, shortly afterwards, the Lymington and Pennington Town Council was created with their offices in the new town hall. In 2012 the New Forest National Park's headquarters were also accommodated in the building.

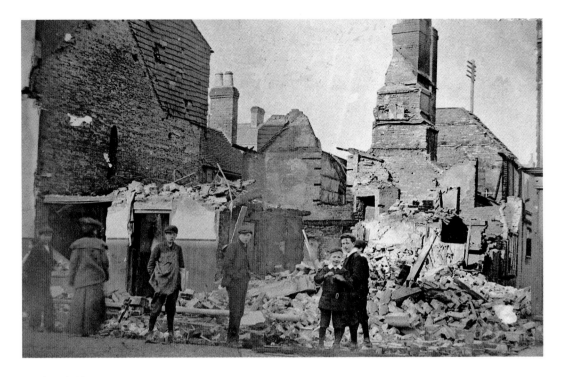

Anchor & Hope

Once one of the many hostelries in the High Street this old established inn, first recorded as the Crown, was renamed the Anchor & Hope in the 1820s. From the mid-eighteenth century it had been one of the important coaching inns of the town. It was burnt down in a fire in 1905 and the ruins in the aftermath are shown in the photograph. Shortly afterwards it was rebuilt in a well-proportioned mock Tudor style and continued to flourish as a pub until the 1970s when declining custom led to its eventual closure. It was then leased to become commercial and retail premises, a role which it continues to fulfil today.

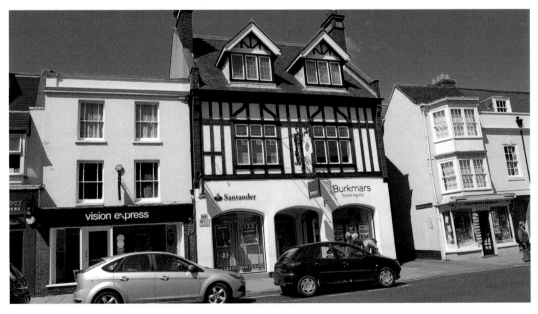

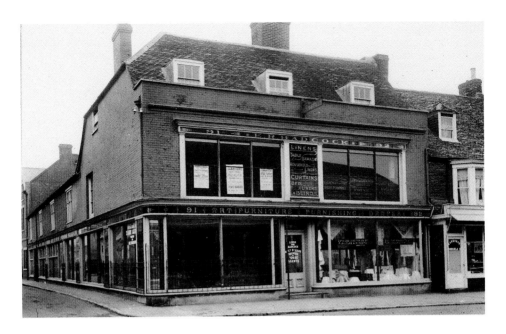

Corner of New Street (Badcock's)

These premises, Nos. 91–2 High Street, were taken over by Edward Richard Badcock in 1895 having been previously occupied by a chemist and a wine merchant. Badcock traded as a silk mercer and cabinet maker but in 1913 he changed the use of these premises to that of an estate agent, whilst continuing his other business interests in premises opposite. Badcock remained here until the Second World War when the premises were taken over by Langham Browne, draper, furniture dealer and undertaker. About 1980 the premises were demolished and a new building erected reflecting the architecture of the time rather than trying to emulate the historic style of a Victorian retailing outlet. Martin's the newsagent occupied the ground floor which subsequently became a Costa coffee shop and the upper floors became offices.

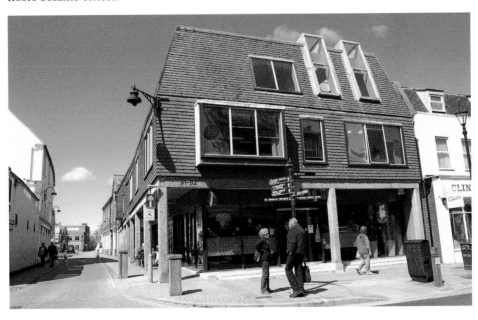

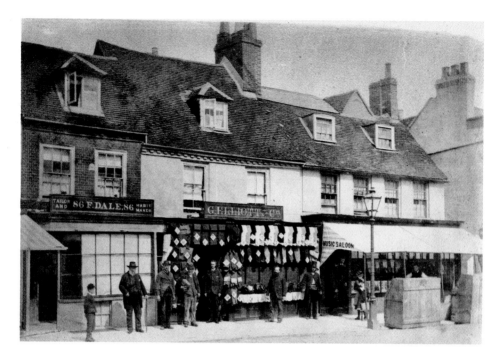

Elliott's First Shop & Klitz Music Shop

George Elliott, the clothier and draper, first occupied these premises in 1873 while Klitz, the music shop next on the right, was founded as early as 1789 by George Philip Klitz, a refugee German soldier who settled in Lymington. Both premises were totally rebuilt at a later date. The Klitz family played a prominent role in Lymington's musical life supplying pianos and musical instruments, in teaching music and becoming church organists. Their shop, which continued trading until 1981, later supplied gramophones, radios and televisions. Dale's, at No. 86 on the left, is the only one of the trio of shops to retain its original form, apparently having undergone only minor refurbishment.

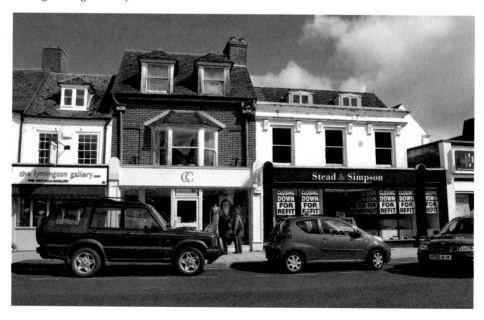

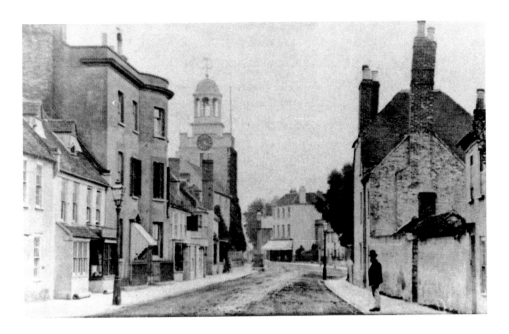

St Thomas Street & High Street

This photograph looks east from St Thomas Street towards the High Street. It can be seen that the two streets are, in effect, continuous but with a kink where the parish church is situated. This helps to explain why in medieval times and later, St Thomas Street was often recorded as the 'High Street in Old Lymington' for the boundary between the two streets also marks the boundary of the borough of New Lymington and Old Lymington. New Lymington was created by charter round about the year 1200 (its exact date is not recorded), but administratively was always within the manor of Old Lymington, a situation which existed until the passing of the Municipal Corporation Act in 1835.

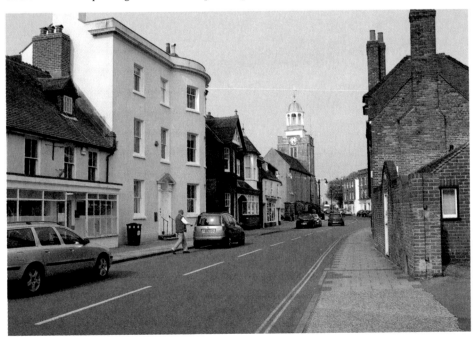

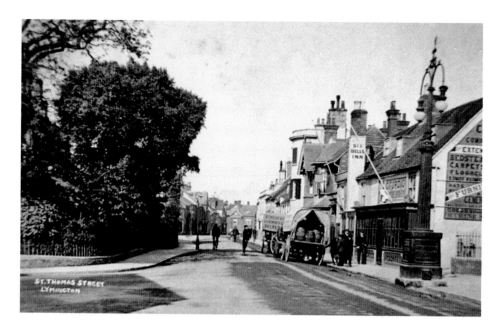

St Thomas Street, Looking West

This early twentieth-century view of the street shows a brewer's dray preparing to unload its barrels at the Six Bells Inn. The monumental cast iron gas column is a dominant feature having been re-sited here in 1858; later it was destined to be located outside the Royal Lymington Yacht Club premises as an historical relic (*see* page 55). The cluster of trees on the left masks one of Lymington's oldest domestic properties, namely, Monmouth House and, also, Quadrille Court both clearly visible in the modern view. The ubiquitous motor car dominates the modern street scene but many of the older buildings are still recognisable.

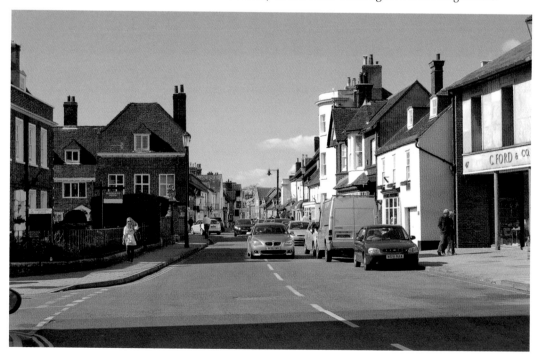

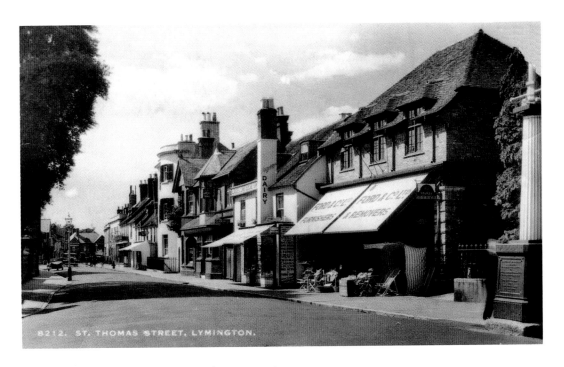

8212. ST. THOMAS STREET, LYMINGTON.

St Thomas Street, Eastern End

On a May night in 1941 the only German bomb to fall on the town itself destroyed Ford's shop, which had been rebuilt as recently as 1927 and is clearly visible on the right. The site stood vacant for twenty years until the shop was replaced in 1961 by a 'contemporary' style building. The old photograph was taken about 1938 and, at that time, the monumental gas standard still dominated the street just outside the west end of the parish church (*see* page 28). Although the façades of several of the buildings have been modified and, noticeably, the tall chimney stack has gone, the street, nevertheless, remains quite recognisable presenting much the same view today as in the past.

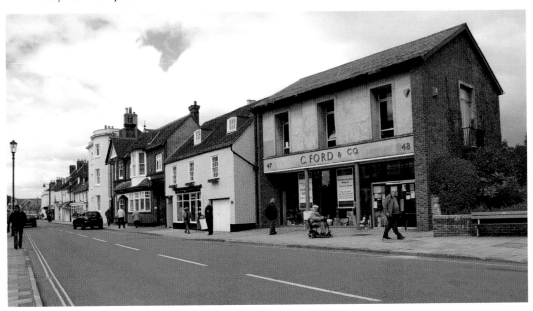

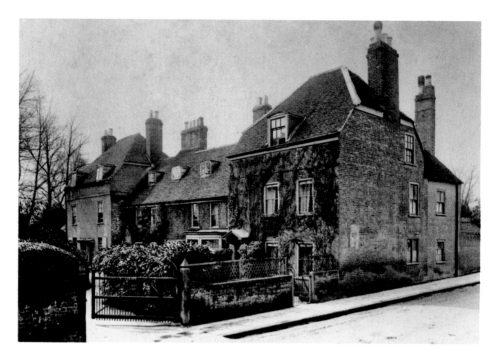

Quadrille Court, St Thomas Street

This attractive range of brick buildings, with a delightful small courtyard, was significantly rebuilt between 1911–13, in a style closely approximating to the original late seventeenth-century terrace. It was used as a barracks by the French Loyal Emigrants at the time of the wars with Revolutionary and Napoleonic France and it is said that the name derives from what was then a popular card game for the soldiers, called quadrille. The buildings are erected at right angles to St Thomas Street and provide residential homes of moderate size and relative seclusion in an urban setting.

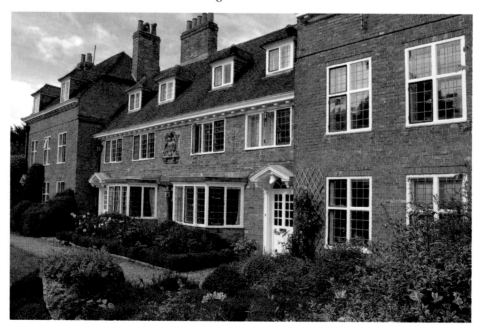

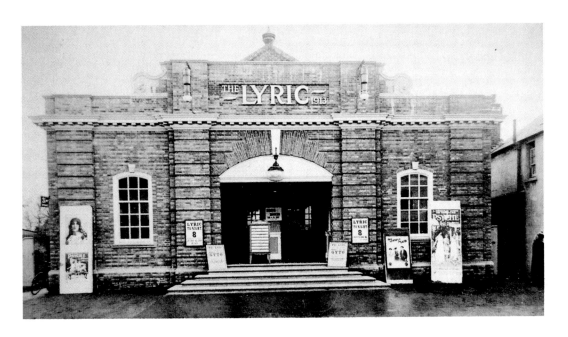

Lyric Cinema

The Lyric Cinema in St Thomas Street was built in 1913 and soon became one of the most popular venues for entertainment in the town but, as with similar cinemas throughout the country, the advent of television saw their speedy decline. Only those that could find a niche market for film shows survived. The Lyric succumbed in 1963 but many of its plush seats were transferred to the cinema in the Community Centre. The large site was taken by an expanding corn and seed merchant, Porter and Clark, and a few years later, following that firm's relocation to New Milton, the Waitrose supermarket built a brand new store on the site which, following their removal to the former Wellworthy factory site, became the home of Marks & Spencer.

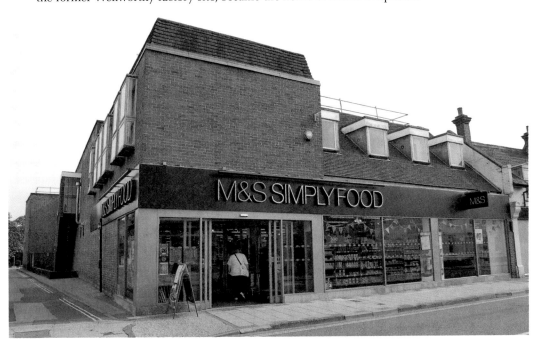

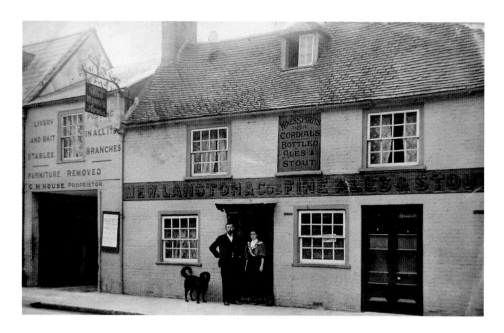

The King's Arms, St Thomas Street

This public house on the south side of St Thomas Street appears to have had its origins in the reign of Charles II and, if that is the case, it is probably his royal arms that provided the name. The publican at the time of the old photograph was a recently retired naval pensioner, George Henry House, born in Lymington in 1868. His wife assisted in the bar. It was owned by Mew Langton whose brewery was on the Isle of Wight and the ales were shipped into the dock alongside the Quay in Lymington. After the First World War the late eighteenth century building was demolished to be replaced by a rather splendid mock Tudor hostelry, timber-framed with latticed mullioned windows, so providing an authentic 'olde world' ambience much in vogue at the time.

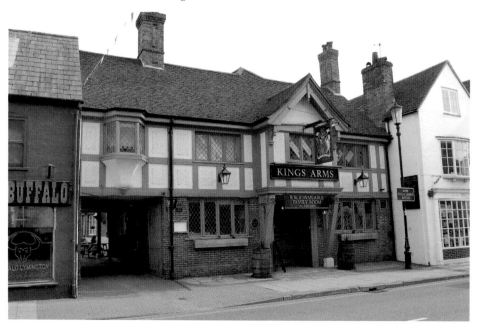

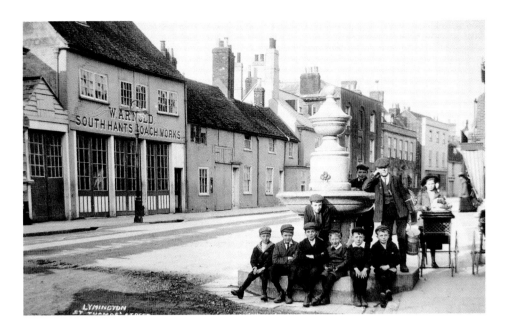

The Drinking Fountain

The west end of St Thomas Street was chosen as the location for a memorial drinking fountain and a horse trough erected to commemorate William Wowen Rooke who died at his Woodside home on the 8 April 1883. Two years later his widow, Persis Rooke, made a gift of these two commemorative memorials to the town in which the family had played such a significant role. Their son, Henry Douglas, was to bequeath Woodside House and gardens to the town in 1927. The decorative fountain is made of polished granite but following street improvements was moved to the Bath Road Recreation Ground for preservation where it remains as a monument though no longer dispensing water. The trough, used for floral displays, is now sited in Woodside Gardens.

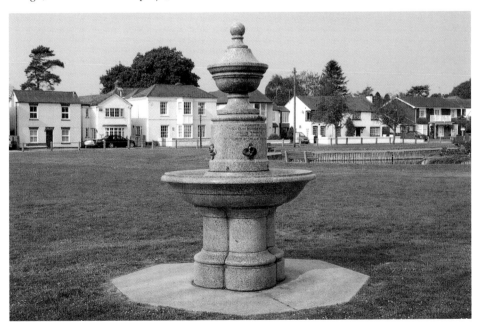

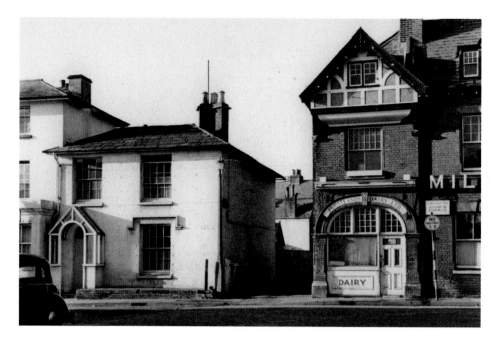

Soapy Lane, Later Called Priestlands Place

This once narrow passage, suitable only for pedestrians and bicycles linked St Thomas Street with the main road, the A337. In the later 1950s voices were raised to have this constricted track opened and widened to create a proper vehicle thoroughfare. This was agreed by the Borough Council so in 1964 the building on the right and some properties behind it were demolished and a new road constructed as can be seen in the photograph below. The house on the left and the fine early nineteenth-century terrace behind it was retained. It now forms part of a triangular one-way system in which the widened road provides the exit route from the town to join the A337 running both north, to Southampton, and west to Christchurch and Bournemouth.

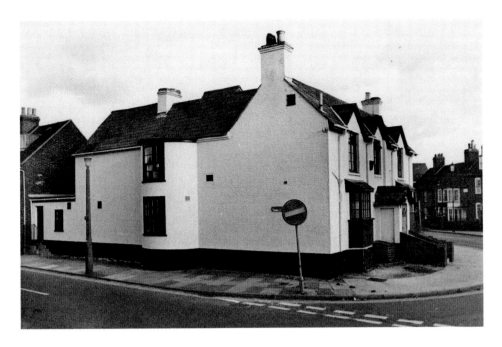

The Wellworthy Club

A fine town house, named Bellevue Cottage, was constructed on this site at the western entrance to Lymington early in the nineteenth century. A later owner named it Reedley House and eventually it was sold to the Wellworthy Athletic and Social Club, an active organisation created for the benefit of employees of the large Wellworthy factory. After closure of the firm in 1989 the club continued to function but eventually was forced to close in October 2005. Following this, two or three schemes were put forward for the redevelopment of this prestigious site but they were rejected. The present development, though a storey higher than the original house keeps closely to the footprint, and was accepted as being much more sympathetic to the ambience of a largely Georgian town. Part of the original garden now forms a triangular 'traffic island' sporting a very fine copper beech tree and attractive flower beds.

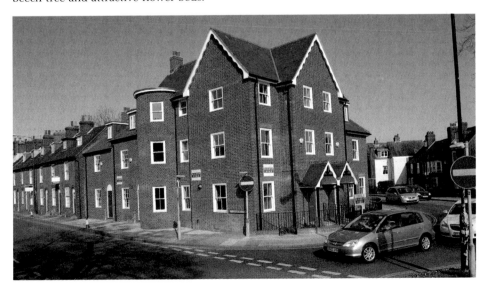

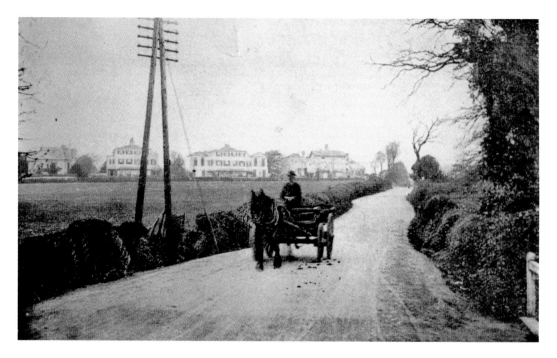

Stanford Hill

Historically through to the present day this is the main route into Lymington from the west. It is named Stanford Hill and forms part of the A337. The stone ford, which gave its name to the hill, was bridged over long ago. The small stream would have run directly across the bottom of the old picture. The open meadow to the left may well be the one recorded in the Domesday Book (1087) for the settlement of Lentune, the name given to Lymington in that great survey. It is now part of the Rowans Park housing estate and wholly screened by trees; only the end house at Highfield (shown near the centre in both pictures) is now partly visible.

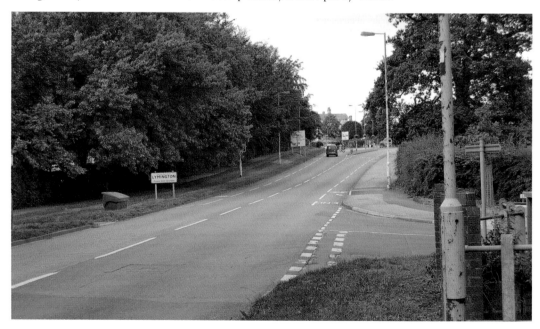

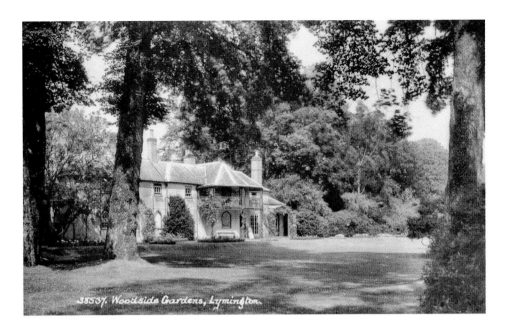

38537. Woodside Gardens, Lymington.

Woodside Gardens

These extensive gardens were bequeathed to the Lymington Corporation by Col Henry Douglas Rooke in 1927. The family had come into possession of this property in 1830. Over the generations they contributed greatly to the town. Their mansion (*above*) was included in the gift but during the Second World War the corporation was unable to maintain the house and it fell into disrepair so that at the conclusion of hostilities and following much debate it was decided the practical option was to demolish it. Happily, the gardens were retained and became a gem in the town for the benefit of residents and visitors. Tennis courts and, more recently, skateboard facilities were added to enrich the value of the gardens for the whole community. The grounds have been maintained to a high standard and provide a valuable haven for the populace at large.

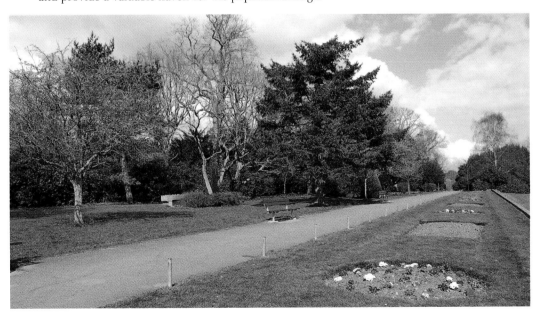

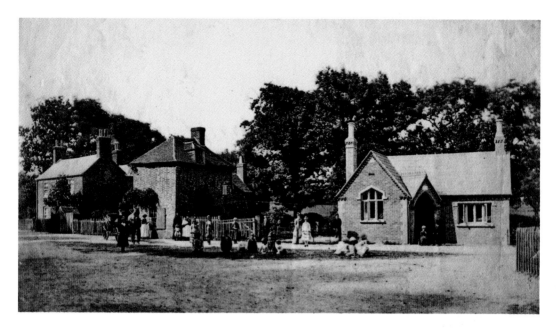

Woodside

A residential enclave lying between the town of Lymington and the coast was known in the middle ages as the 'Township of Woodside' and there was an altar dedicated in that name in the parish church. It has always been rural and agricultural but in the last half of the twentieth century has undergone significant changes; many of the old cottages have been demolished and new roads and housing constructed. The small Sunday school, founded in 1877 by a local benefactor, Francis Crozier, in memory of his wife, survives as a private residence still retaining its bellcote, Gothic doorway and memorial stone. The cottages that once stood on either side of the school have gone. Francis Crozier lived in a large thatched *cottage orné*, which survives nearly opposite and is now named Delawarr House. Notable figures in Lymington's story, successively resided there, including Robert Hole, founder of the Lymington Community Centre, and Algernon St George Caulfeild, who presented the first X-ray apparatus to Lymington Cottage Hospital shortly after it was opened (*see* page 67).

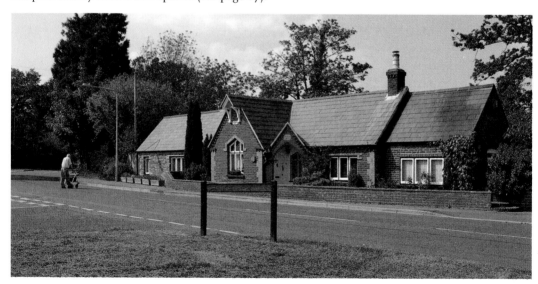

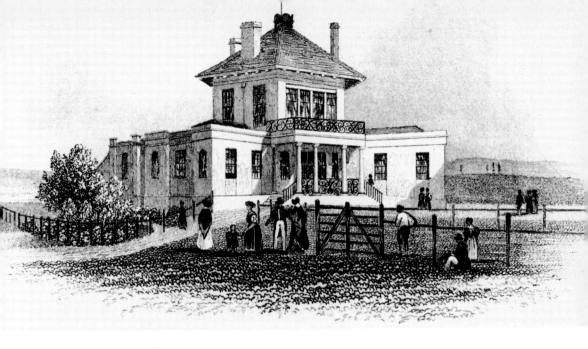

The Sea Water Baths

The Lymington baths are recorded as early as 1777 when the first bathhouse was built, but they appear to have enjoyed something of a chequered history until the Lymington Bath Improvement Co. was established to provide a more systematic regime in 1833. The Bath House built around that time, shown above as it appeared in 1850, still survives as the Lymington Town Sailing Club's headquarters. Despite being described as the largest sea water baths in the south of England (probably correctly) and well patronised, they never quite seem to have enjoyed the hoped for success. The Corporation took them over in 1929 and currently there is discussion about their future use. The lower picture shows them drained for cleaning.

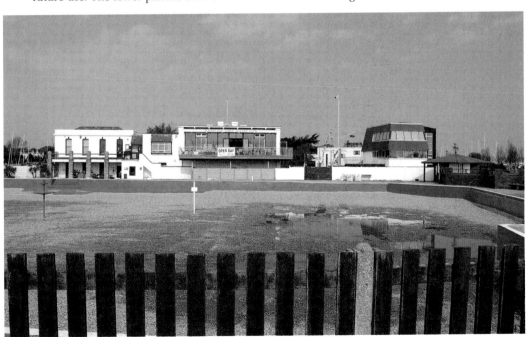

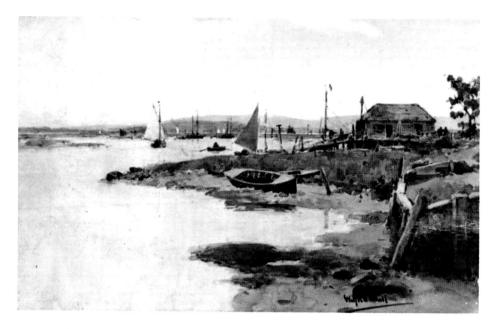

Dan Bran's Shed & The Lifeboat Station

The building shown in the picture above was known to generations as 'Dan Bran's Shed', named after one of the truly remarkable characters of the Lymington River. Renowned as a boat builder with an exceptional understanding and appreciation of the life pursued on and around the waters of Lymington and the Solent, he became something of an institution in his own right. Mysteriously, some twelve years after his death, the shed burnt down in the summer of 1962. The Royal National Lifeboat Institution's modern lifeboat station is located not many yards away from where the famous shed once stood and performs the role for which the RNLI has become deservedly famous throughout the waters that surround our country.

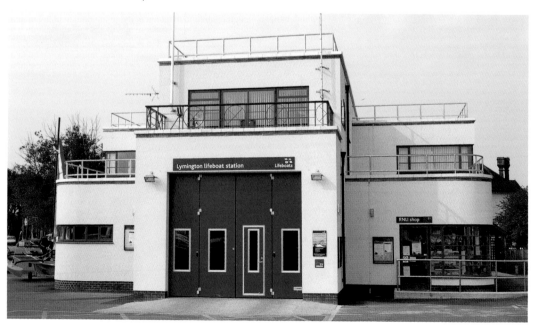

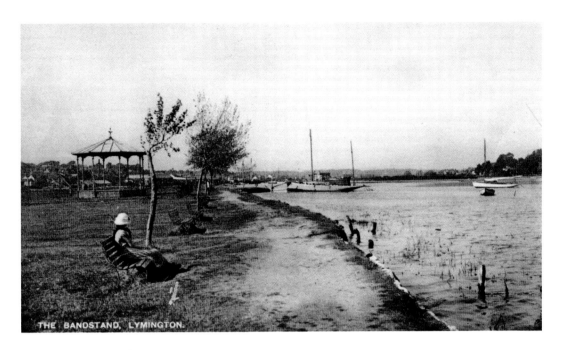

THE BANDSTAND, LYMINGTON.

The Bandstand

Bandstands exist in the public gardens of most towns. The one erected in the Bath Road Recreation Ground alongside Lymington River probably came into being in late Victorian times. Lymington had its own town band which played there on Sunday afternoons and other bands were invited to entertain a public with an appetite for the popular tunes and classics played in such a favoured location. At some unrecorded time after the Second World War the old bandstand disappeared and was not replaced until the millennium of 2000 when the town council decided to build a replacement at the cost of £65,000. While retaining the essential characteristics of its predecessor it is rather grander with accommodation below the platform for deckchairs and other accoutrements. It continues as a summer attraction for local people and visitors.

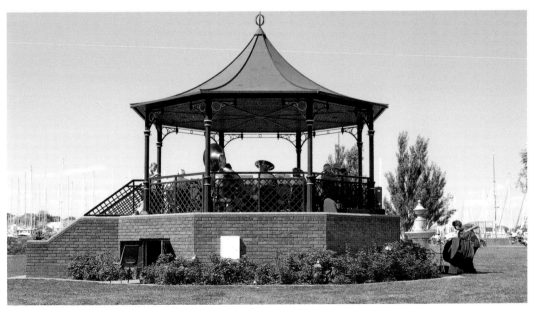

Forest Ponies

Until 1964, when for the first time the New Forest was fenced along its entire perambulation and all the access roads gridded, the forest ponies wandered freely in the town of Lymington and here a pair is seen in the public gardens in Bath Road. Wherever possible the animals were rounded up and confined in a pound in Woodside Gardens. The photograph was taken in August 1960. The Bath Road gardens, still very much enjoyed by residents and visitors for relaxation, are now free of animal droppings which could be a nuisance though no doubt appreciated as free manure by some of the gardeners residing in the houses in the adjoining Bath Road.

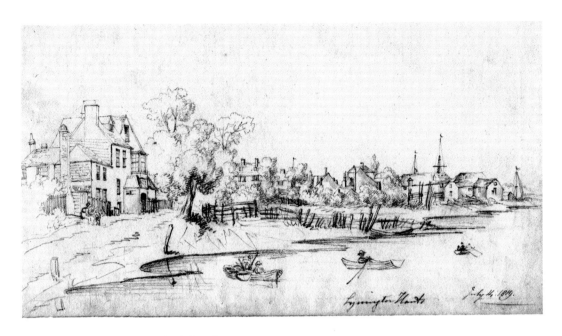

Press Gang Cottage, Bath Road

Until recently a wooden plaque was displayed on the property which read, 'The Harlequin Inn, HQ of the Press Gang *c.* 1800' At that time there was a clear view from the inn of all the ship movements on the river and therefore the opportunity of establishing the arrival of seamen who would be likely candidates for 'recruitment' into the Royal Navy. Today, the Harlequin Inn has been converted into a cottage. The width of the river at this point has been marginally reduced and the road to Lymington's major yachting and boating facilities improved. The pencil sketch was made in July 1819.

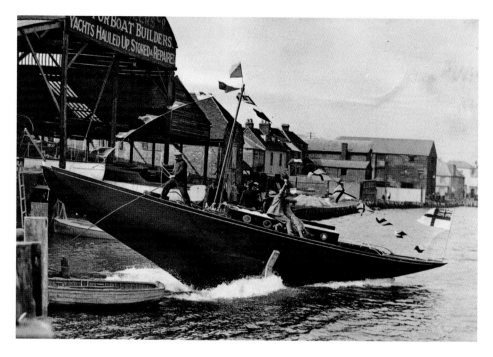

Boat and Yacht Building

Today Lymington is renowned as a Mecca for yachting, boating and a range of leisure pursuits connected with the water. It enjoys a favoured location on a tidal river estuary with access to the waters of the Solent. Since 1817 developing and sustaining this activity has been of major economic importance. Joseph Weld is credited with being the catalyst that established yacht building and the arrival of Thomas Inman, a renowned boat builder, in 1817 assured the future of the industry. Inman became a major constructor and when the family ceased trading their shipyards passed through a succession of owners until purchased by the Revd Edward Berthon of Romsey. Following the death of his son in 1917 the business passed to the May family who continue to trade as the Berthon Boat Company Ltd.

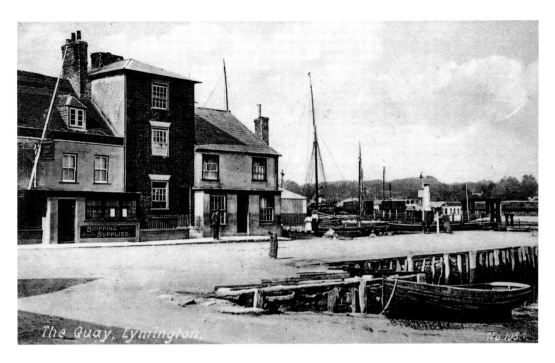

The Quay, Lymington. No. 105.

The Town Quay

Historically one of the most important areas in Lymington, it certainly predates the creation of the Borough and was designated as falling within Old Lymington until 1405. From that date onward the maintenance of the quay was a constant charge on the burgesses and levies were taken on cargoes shipped from or landed on the quay to help defray expenses. Alongside the quay, seen in the foreground of both pictures, is the Lymington Town Slip initially created as a small dock where ships could be hauled up for repair; it had a ramp to permit ships to be drawn clear of the water. The Ship Inn, seen as the taller structure, has a long history but was rebuilt in 1936. At the extreme left of the terrace was the Yacht Inn.

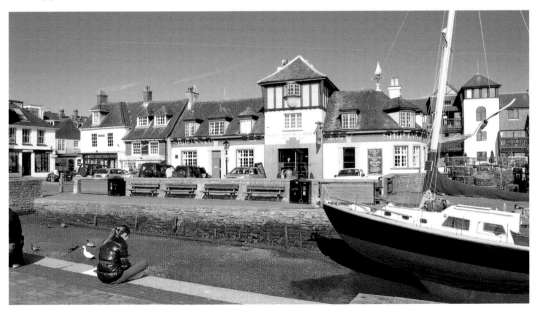

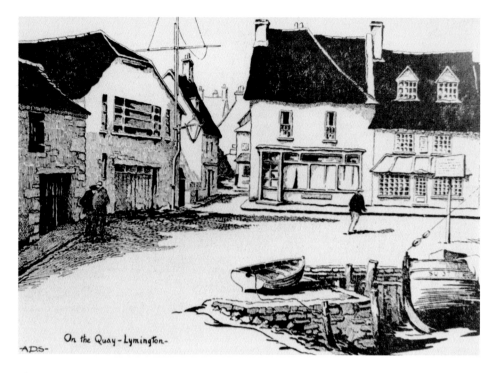

On the Quay - Lymington -

ADS-

The Town Quay

The Quay area was always one of the most economically important parts of the town and over the centuries the corporation paid large sums of money to maintain it. Ships engaged in both the coastal and international trade called here to load and unload cargoes. The abbeys of Beaulieu and Quarr, both Cistercian houses, had salt warehouses here and the stone wall, above left, may well be a part of such a building. Unfortunately, it was destroyed in recent development leaving only a token piece of wall; the remains can be seen below. Today, the Quay area is extremely popular and busy with the boating and yachting community as well as crowds of sightseers. Many of the businesses sited around the Quay are connected with maritime activities.

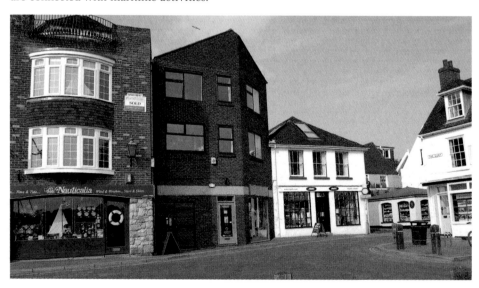

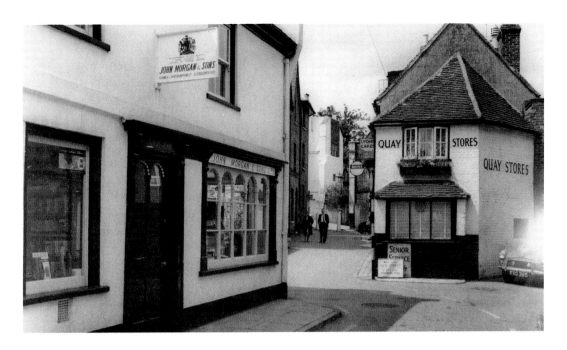

Quay Street

The little alleyway that leads from Quay Hill through to the Quay has long been one of the most picturesque scenes in urban Lymington and has now been pedestrianised to make it even more accessible for tourists and residents to enjoy. The tarmac road surface has been replaced by stone setts. It still retains its medieval layout and once fell within the purview of Old Lymington and was probably the ancient maritime settlement before the Borough of New Lymington was created in the late twelfth century. It was incorporated into the Borough of New Lymington through the charter issued by Edward Courtenay in the year 1405.

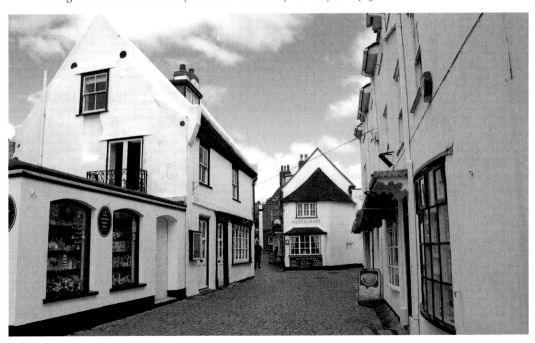

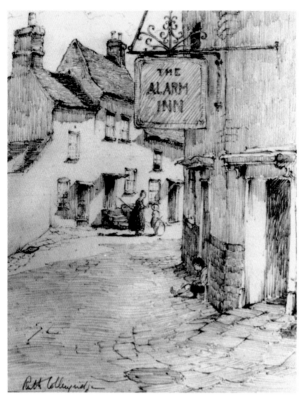

The Alarm Inn

This was just one of the seven hostelries clustered in the Quay area in the later nineteenth century. It was named after one of the most famous yachts built by Thomas Inman of Lymington for the famous yachtsman, Joseph Weld in 1830. The inn opened in 1850 and the first landlady was the appropriately named Jane Harbour, called a 'Retailer of Beer' in the 1851 census. It closed in 1923 not long after the delightful pencil sketch drawn by Ruth Collingridge shown here. Today it is a private residence but proudly proclaims its earlier history on a large painted sign which names it the 'Old Alarm Inn' and states that the property was built *c.* 1680 though plainly the building we see today cannot be earlier than the late eighteenth century.

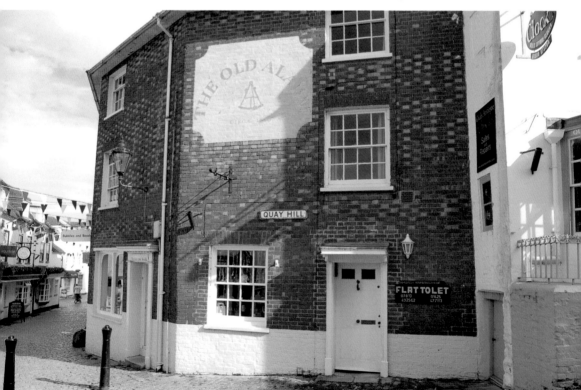

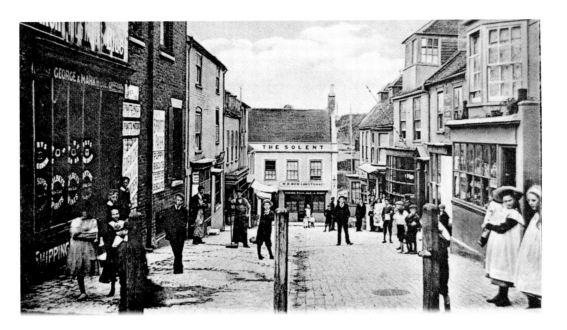

Quay Hill

Quay Hill leads from the High Street to the Quay and harbour. As can be seen from the early photograph, published as a postcard, it is a busy commercial area with retailers' premises situated on both sides and an inn, the Solent, closing the view at the bottom. Today it is still the favoured route to the Quay for pedestrians and is very popular with tourists and visitors. The shops have decreased, but the overall scene has little changed. Many of the buildings on the right hand side have their origins in the eighteenth century, but have undergone restoration and modification; those on the left are mainly nineteenth-century.

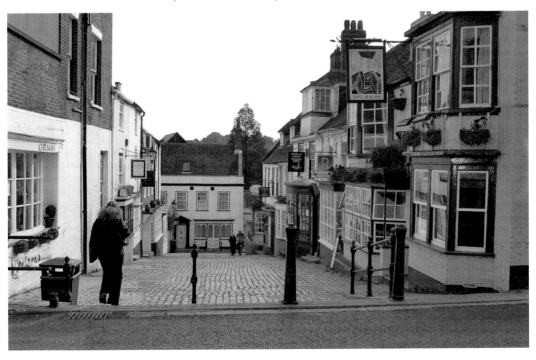

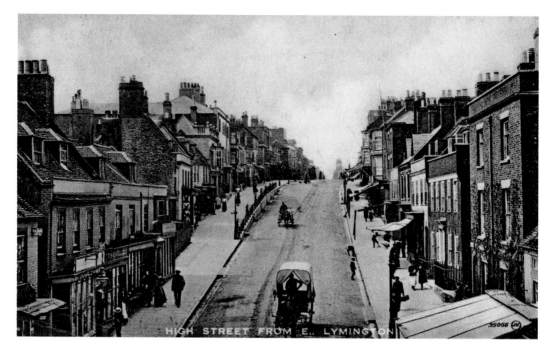

Town Hill, High Street

This part of the wide High Street, often referred to as 'Town Hill' is, geographically, part of the western bank of the Lymington River. The street was created about 1200 under the charter granted to the townsfolk by William de Redvers, 5th Earl of Devon and forms part of the borough that runs from the parish church eastwards to the bottom of the hill. Some of the properties on the left still have frontages of the width of the original burgage plots. It remains an integral part of the commercial and retailing life of Lymington.

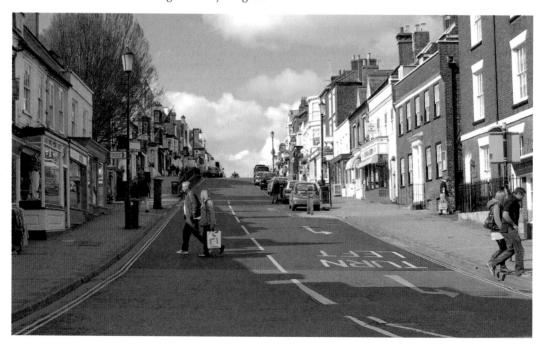

The Old Police Station

The Hampshire County Constabulary was only established in Lymington in 1853 and initially comprised just two resident constables. Their first station was established near the tollhouse at Buckland but two or three years later they took up residence in a house once owned by Dr William Towsey in Gosport Street and this remained the town's police headquarters continuously until 1952 when a replacement was constructed near the hospital in Southampton Road. The now redundant police station then became a restaurant, a role it fulfils to the present time.

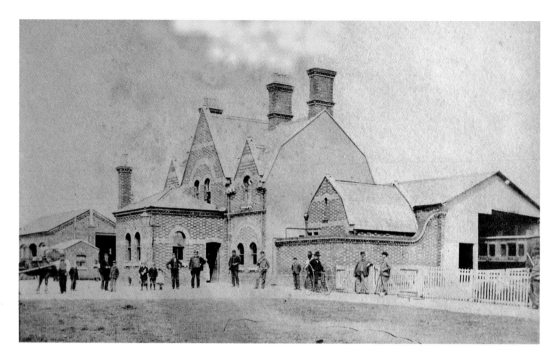

Railway Station

The commercial opportunities resulting from the opening in 1847 of the Brockenhurst Railway Station on the main Southampton to Dorchester line was not lost on Lymingtonians who lobbied for a branch line to be built. This was completed in 1858, the station being opened in the following year. By 1861 the line had been extended to a jetty permitting Isle of Wight ferry steamers to berth alongside. The modern station in appearance gives the impression of a little changed 'original' building but a comparison with the *c.* 1870 image reveals a clever and sympathetic change to the front which with other general improvements now gives a crisp sharp building.

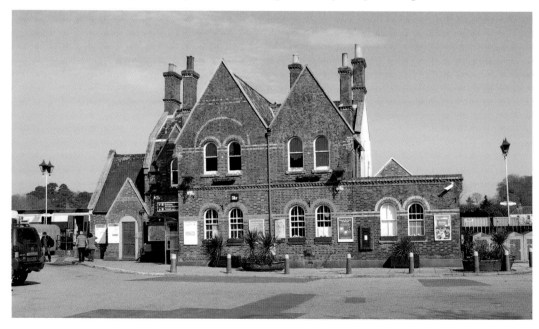

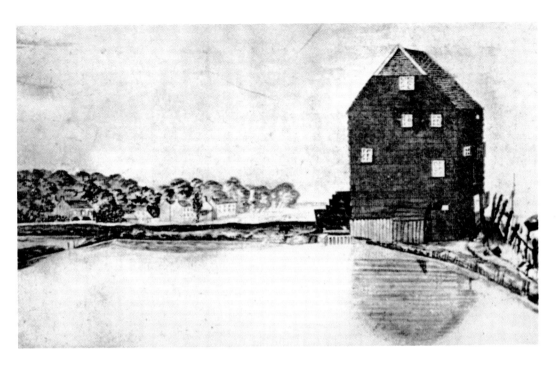

Lymington Mill

Lymington possessed a tidal corn mill for a long time. The old picture, looking down stream, shows the mill house standing on a small embankment acting as a dam to the tidal pool. The waterwheel can be seen to the left of the building. The corn mill had become a timber saw mill by the time the railway arrived in 1858 and in order to accommodate the line and a new station, part of the millpond, to the left in the picture, was filled in. This work was completed by the autumn of 1858 when Lymington terminus station, as it was then known, was opened. A temporary station had been used since the official opening of the line in July 1858. The saw mill continued to operate for a few years after the arrival of the railway, but when it eventually ceased operation the remaining part of the mill pond was filled in and the land reclaimed for commercial use.

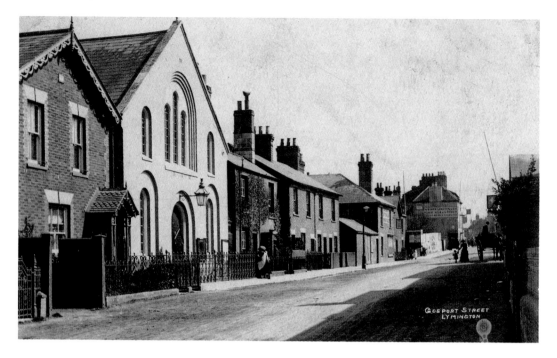

Gosport Street & the Methodist Chapel

This ancient thoroughfare, recorded in the earliest surviving records of Lymington, in part marks the eastern boundary of the first chartered borough of about 1200. In more recent history it has been a road of mixed use being partly commercial and partly residential as it remains to the present day. The dominant building on the left is the Methodist Chapel, which was built in 1859. It closed in recent years and the Methodist worshippers in a truly ecumenical way now share All Saints in Woodside with the Anglicans (*see* page 79).

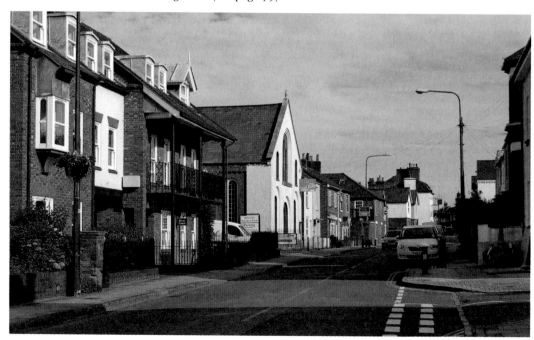

The Gas Works & Gas Lighting

Lymington produced its own gas from 1832 and in the same year installed gas lighting in the main streets of the town. During the next decade or so gas services were laid increasingly into commercial and residential premises. The original iron gas columns were provided by Sir Harry Burrard Neale while his brother donated the actual lamps. This munificence was commemorated on cast iron panels at the base of a large ornamental lamp, which was first sited outside the town hall standing in the street, but when this was demolished in 1858 it was moved to a position near the west end of the church. When gas was superseded by electric lighting the lamp was repositioned outside the Royal Yacht Club where it remains to the present day. The modern picture shows the site of the gas manufactory now absorbed into an industrial complex.

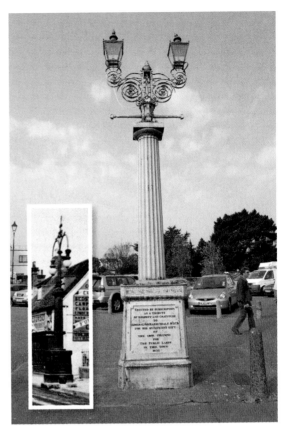

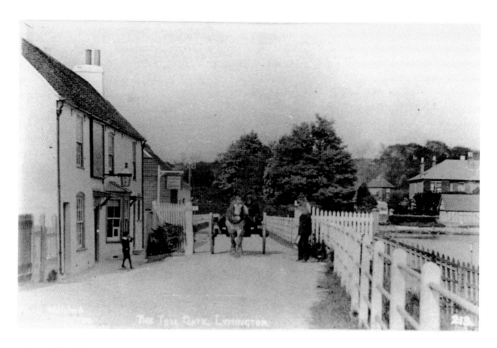

The Toll Bridge

In 1731 a Captain Cross constructed a causeway with a bridge across the Lymington River and initiated a charge for all those using this new route. It lay more than a mile south of the existing bridge at Boldre and proved very convenient. However, Lymington Corporation objected to the whole project and took the matter to court complaining that the causeway was responsible for silting which interfered with the operation of the harbour. The case was lost and the causeway with its bridge remained. The house for the toll gate keeper is on the left. Later the railway company took over the bridge and collected the tolls but they were bought out by the Hampshire County Council in 1955 and a few years later the tolls were discontinued and the buildings demolished.

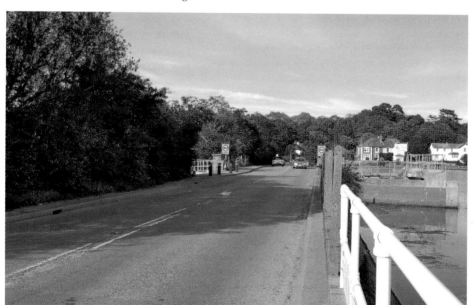

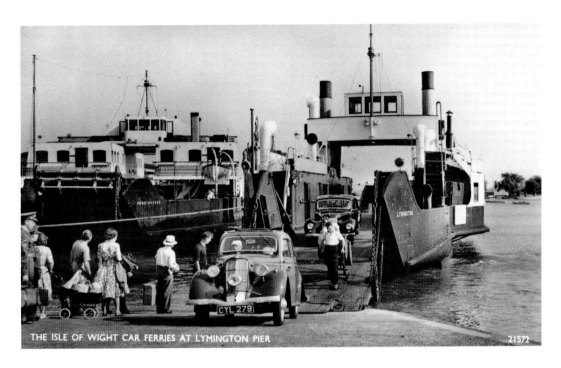

THE ISLE OF WIGHT CAR FERRIES AT LYMINGTON PIER 21572

The Ferry Terminal

This terminal was built in 1884 on the eastern side of the river when the railway was extended. But since that time there have been many changes. In the old photograph of around 1950 the *Lymington* discharges its cargo of cars (it was designed to carry sixteen) and passengers while those waiting to board pause on the slipway. Today the ferries are much larger and passengers board and alight through a dedicated enclosed passageway. The mooring position for the ferries has also been moved about two hundred yards further south from its original position. The *Lymington* came into service as the first 'roll on roll off' ferry in 1937 and ten years later was joined by the larger *Farringford,* seen on the left in the photograph.

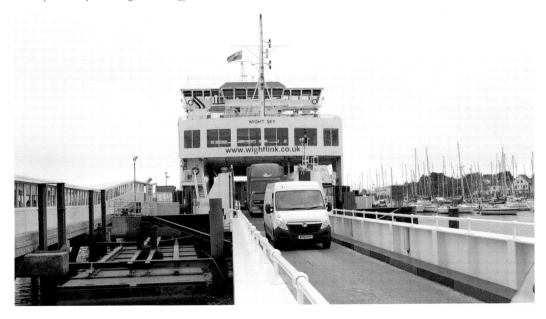

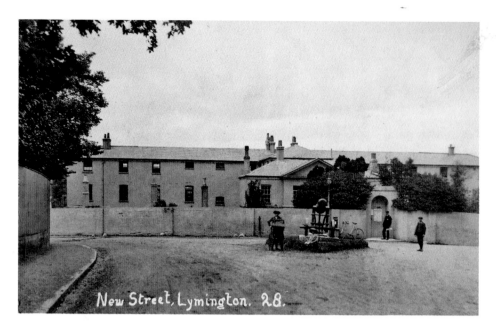

New Street, Lymington. 28.

The Workhouse

The Union Workhouse was built in 1838 just four years after the passing of the Poor Law Amendment Act which required that groups of parishes should unite for the more efficient maintenance of the poor. Lymington became the centre for the Lymington Union of parishes which, in addition to Lymington itself, included five surrounding parishes, namely, Boldre, Brockenhurst, Hordle, Milford and Milton. It operated with all the vigour and discipline that is associated with the workhouses of this period but gradually, as the nineteenth century progressed, so conditions were ameliorated. After it ceased to be a workhouse in 1928 it became an infirmary providing wards for the elderly but incorporated other hospital functions such as provision for out-patients and, also for a period, acting as a maternity hospital. After final closure and following further conversion it outwardly retains its original appearance but now provides high quality accommodation in flats and apartments.

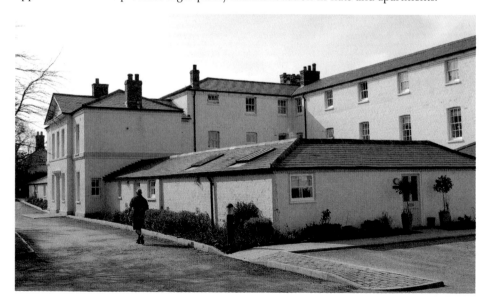

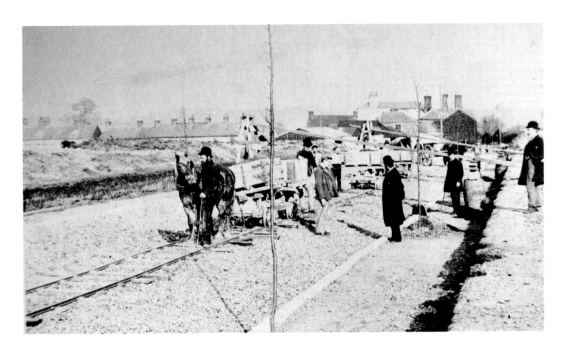

Avenue Road

Between 1895 and 1899 a new road, running east-west was constructed to create a more convenient link with the town and Southampton Road. It was built across Barfields, the ancient common fields of the borough, and was initially named Barfields Avenue. It is interesting to see the temporary railway laid to assist the distribution of hardcore for the road's foundations, which was largely in the form of chalk rocks. Trees are already in place along the pavement edge. The Borough Arms, still a functioning hostelry, is the dark building visible at the end of the road in the upper picture and white in the lower. Today Avenue Road is a busy and important route avoiding the often congested St Thomas Street and High Street and in doing so providing a convenient link with the Isle of Wight Ferry terminal.

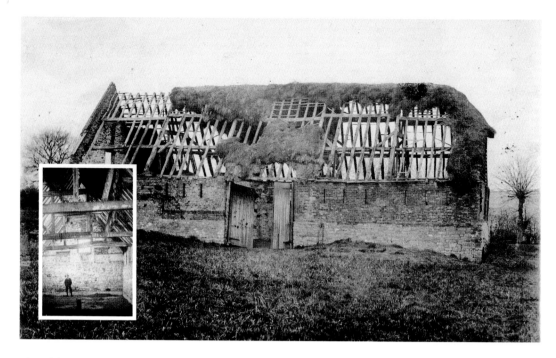

The Tithe Barn

Lymington possessed a fine medieval tithe barn, built primarily from stone. Bearing in mind that stone was not available in the area the cost of constructing the barn must have been considerable and reflects its importance to a community still largely engaged in agriculture. However, its significance declined as the town became more commercial. During the French Revolution, when hundreds of French Loyal Emigrants settled in Lymington, it was used as both their barracks and as a hospital. Following the end of hostilities the barn fell into total disrepair and was demolished in 1926. The town council acquired the land in order to build a large council housing estate, appropriately named Tithe Barn.

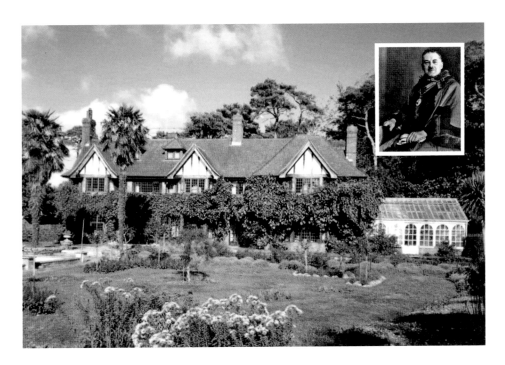

Ravenscourt

When the entrepreneur John Howlett (1883–1976) came to Lymington as a motor mechanic in 1912 no one could have guessed what an impact he was to have on the town. He joined South Coast Garages and eventually was able to take over the business and in 1919 he founded Wellworthy Piston Rings Ltd, a firm which became a major player in the automotive industry and employed thousands. As his wealth grew so did his aspirations, so much so that he became councillor and then mayor of the Borough of Lymington. In about 1930 he was able to acquire land at Buckland upon which to build a fine residence as shown above. Following his death in 1976 the land was sold and then developed into a high quality housing estate, called Ravenscourt, after the house he had created.

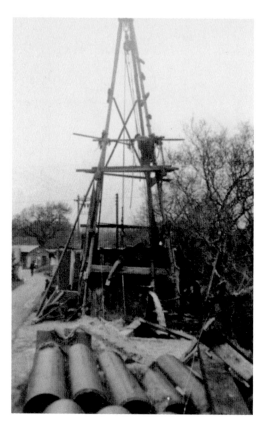

Water Supply

Lymington had for centuries obtained its water from wells, including a communal well near the Market House. The demands of the nineteenth century ensured that a more secure and regular supply should be found and after an abortive attempt to make a borehole at the west end of town, it was decided to drill at Ampress at the north end of the parish. The drilling derrick was erected at the site and the borehole proved immediately productive. Water poured forth as shown in the old photograph. Drilling first produced water in 1904, which was piped directly to the water tower in town but in 1931–2 a new much larger water tower was erected on the edge of the Iron Age hill fort at Buckland Rings to supplement the one in town. Today the well is owned and operated by Sembcorp and continues to reliably provide water for the surrounding populace. The well is a far from dramatic site and today is screened by secure fencing and hidden away in a corner of Ampress, where once there was an Iron Age dock or landing place for their primitive vessels.

The Lymington & New Forest Hospital

This large modern hospital costing £36 million, stands on ground purchased by the League of Friends of the Hospital; it was funded under the Public Finance Initiative and constructed early in the twenty-first century. Formerly this had been part of the Wellworthy Ampress factory but following its closure in 1989 the site became vacant. The hospital was formally opened by Princess Anne on 6 February 2007. The hospital is equipped with access to all the modern facilities of medical science, but its origins as the Edward VII Memorial Cottage Hospital are preserved in the foundation stone, now displayed near the entrance, and in the descriptive name stone standing in the centre of the roundabout.

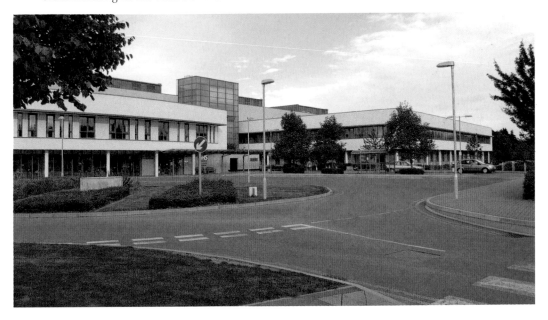

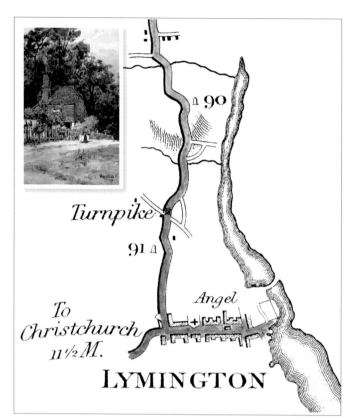

Buckland Toll House

Mogg's map of 1817 shows the position of the tollhouse where the word 'Turnpike' is inscribed. The long since defunct turnpike tollhouse, shown in the painting (*inset*) by Wilfred Ball in 1911, was situated at Buckland on the road to Rumbridge (for Southampton and Salisbury), and was presumably built at the time the turnpike trust was established in 1765. It has not greatly changed externally though its life as a tollhouse ended in the mid-nineteenth century when it became a residential cottage occupied continuously until 1952. It was restored between 1984–6 and for a few years became the Toll House Museum.

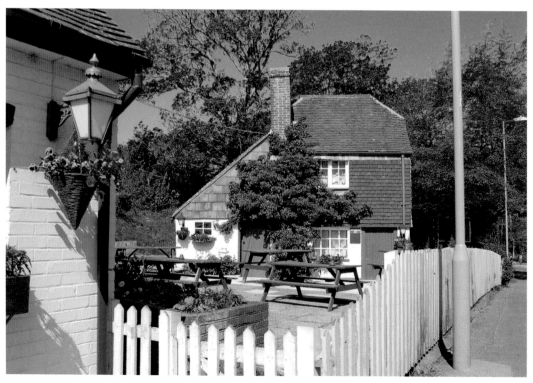

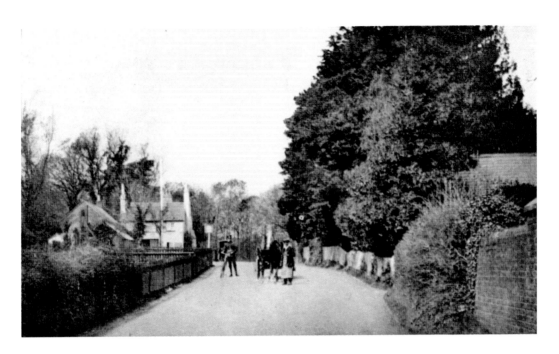

The Crown Inn, Buckland

It would not be possible today to emulate the figures posed in the old photograph called 'On Brockenhurst Road' as it is the extremely busy route now known as Southampton Road. It is the A337 and is the primary route leading north from Lymington. However, the area still retains its rural character despite a modicum of development both near the Crown (now renamed the Tollhouse) itself and on the opposite side of the road. The Iron Age hill fort, Buckland Rings, lies behind the trees. This remains a fine trivallate hill fort with distinctive banks and ditches and an open area used as an agricultural field. It has been subject to one major excavation and several minor ones. Attempts to develop it were decisively thrown out after a major planning battle in 1988. To ensure its future preservation as public open space the whole hill fort area was purchased by Hampshire County Council.

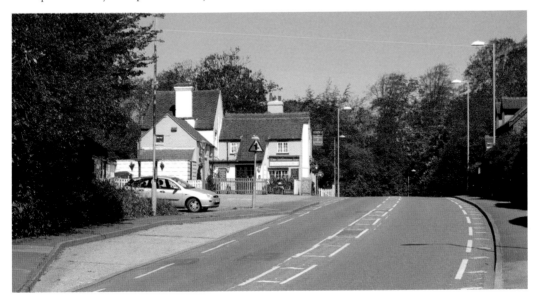

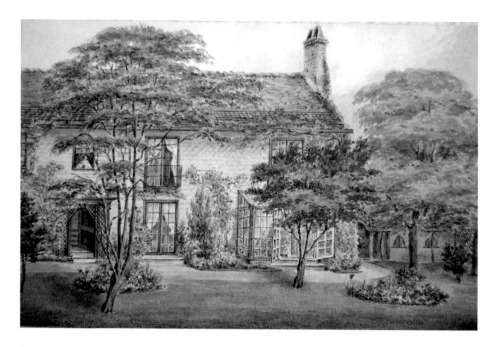

Buckland Cottage

This eighteenth-century cottage was greatly extended in the later nineteenth century. It is significant as the home of Lymington's most renowned poet, Caroline Bowles (1786–1854). After the publication of some of her earlier works she began correspondence with several leading literary figures, none more prominent than Robert Southey, the Poet Laureate. Following the death of his wife, Edith, in 1836, a romance developed between Caroline and Robert, and despite her initial refusal of his proposal of marriage, made during a visit to Buckland, she finally agreed and their wedding took place at nearby Boldre Church in June 1839. Unfortunately, she was not welcomed by his family and this, together with his rapidly failing health, led to several years of unhappiness for Caroline. Following Southey's death in 1843, she returned to her beloved Buckland home for the remainder of her days.

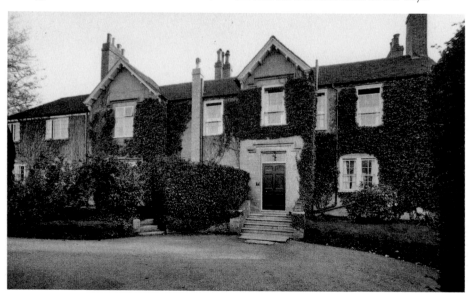

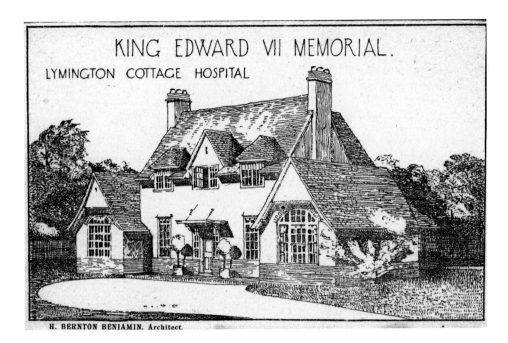

KING EDWARD VII MEMORIAL.
LYMINGTON COTTAGE HOSPITAL

H. BERNTON BENJAMIN. Architect.

Lymington Hospital

Lymington's first hospital was opened in 1913 as a memorial to Edward VII. It was typical of the 'cottage hospitals' built in many towns around that time. Initially, it had two four-bedded wards and a single bed emergency ward all heated with open coal fires. The land on which it stood was donated by Keppel Pulteney, then lord of the manor. The nursing complement consisted of a matron and one Irish nurse. Local doctors undertook the duties of consultants. Its accommodation and facilities proved to be inadequate and improvements were introduced including X-ray equipment provided by Algernon St George Caulfeild of Delawarr House, Woodside. Voluntary support was a vital component in its success and John Howlett was among the many wealthy benefactors. But the general public was always unstinting in its generosity. One of the later matrons, Miss Marion Buckeridge, commented the hospital, 'was started by Lymington people, belonged to Lymington people, and served Lymington people'. It was demolished in 2002 and a housing estate was built on the site (*see* page 63).

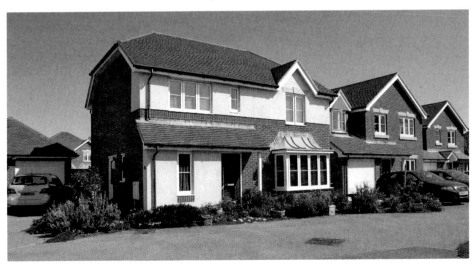

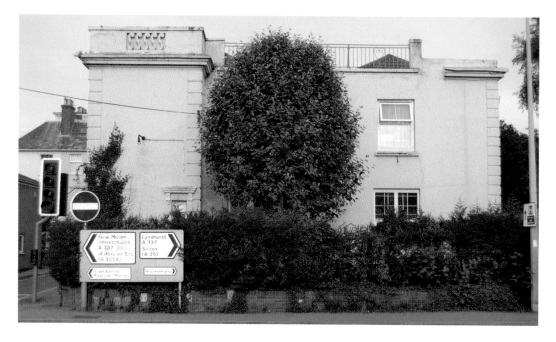

Apsley House or Buckland House

This fine residential property stood in a commanding position just beyond Buckland Terrace. It was a good example of the quality properties being developed at the western end of the town throughout the 1830s and 1840s. In its later years it served a number of purposes. For many years it was a nurses' home for those working in the nearby hospital and later it became the Conservative and Unionist Club. When the club relocated, the building had a chequered history and developers were eventually able to purchase the house and demolish it. The picture below shows a replacement building during erection in 2012; it is due to become 'Fine New Homes' rather than the single family residence it once was.

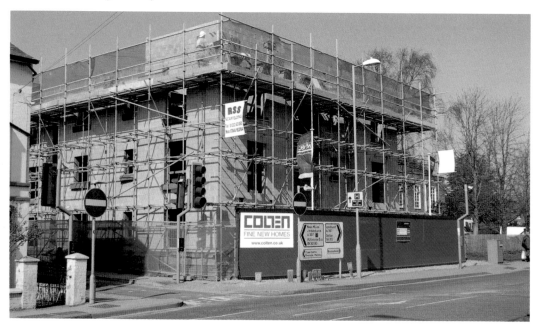

Buckland Terrace

This shows a terrace of 1840s houses built at the western end of the town. Today they look very much the same. The Irvingite Chapel, more correctly known as the Catholic and Apostolic Church, visible on the extreme left, had a relatively short life from 1838 to the last decade of the century. It was then sold and a large red brick semi-detached house was erected on the plot. The chapel belonged to a denomination founded by Edward Irving (1792–1834) in 1832. The 1851 Religious Census revealed that the denomination had only two places of worship in the whole of Hampshire. The houses in the terrace are each different architecturally and represent the kind of nineteenth-century housing being built mainly for the middle class professional and business families.

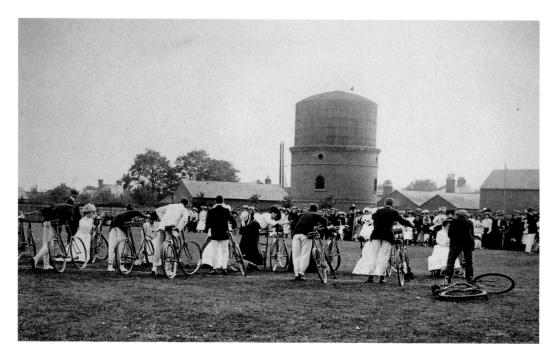

The Water Tower

Lymington's first water tower was a large plate steel cylinder supported on a circular brick base. It was surmounted by the fire bell, just visible above the dome of the tower. The first well was drilled nearby but as it continually clogged with sand it had to be abandoned. The new artesian well at Ampress, about a mile to the north, then supplied the water, which was pumped to this tower for storage (*see* page 62). Its importance declined once the larger one was constructed at Buckland in 1931. However, the original tower survived until well after the Second World War when it was demolished. The site on which it once stood became a small car park.

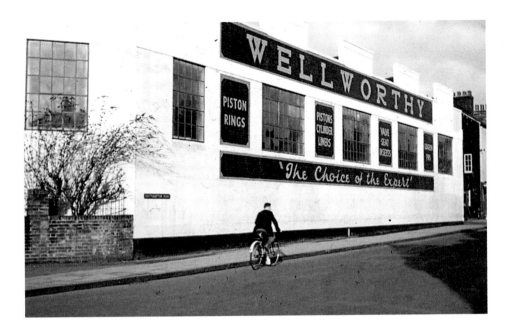

Southampton Road, Southern End
Instead of a factory wall with a row of regular windows punctuated by product advertising the scene is now much more open fully in keeping with the *Lymington Conservation Appraisal* of 2001, which recommended that the area should be retained as open green space. The undemonstrative green Waitrose name, high up in the gable, replaces the dominant Wellworthy and 'The Choice of the Expert' slogan, but sadly modern street furniture clutters the more spacious foreground created by the widened road. The first house of Southampton Row, just visible behind the bulk of the factory building now enjoys an open vista.

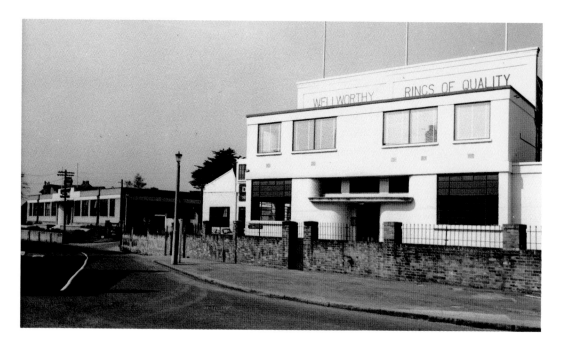

The Wellworthy Site

The administrative buildings of Wellworthy Ltd are shown in the photograph. This engineering firm started in 1919 on this site first manufacturing piston rings later expanding into a range of related automotive parts, including cylinder liners and pistons. It played a prominent role in the Second World War by supplying pistons for the Rolls-Royce Merlin engine used to power the Spitfire and other aircraft. John Howlett, the founder of the firm had come to Lymington as a motor mechanic (*see* page 61) in 1912. The factory buildings extended behind the office buildings, as shown above. When the firm closed in 1989 the site was sold and Safeway built a large supermarket, later to be taken over by Morrisons and, more recently, by Waitrose. Much of the area occupied by the factory has been converted into the customers' car park.

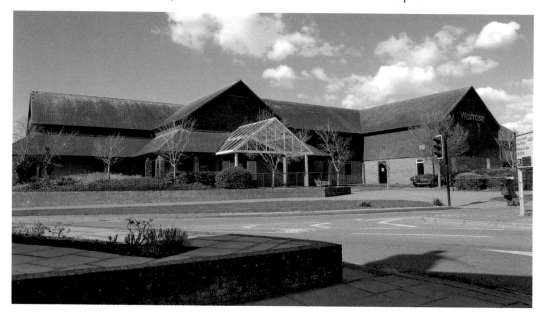

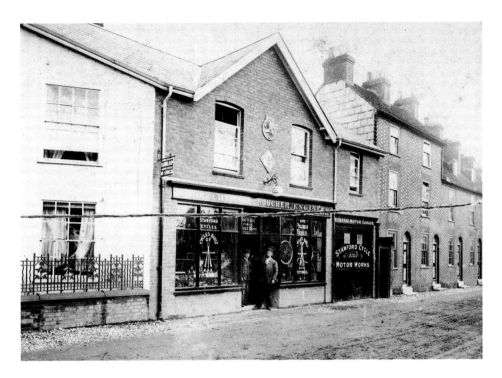

Croucher's Garage

One of Lymington's earliest motor garages was established in Stanford Road. It started life as a cycle works in about 1900. By 1907 the firm was trading as Benjamin James Croucher & Son, cycle and motor engineers and agents. Its business was successfully continued into the 1960s, though by that date a partner had been introduced. It is interesting to consider this small family business flourishing immediately across the road from the huge Wellworthy piston ring factory, formerly the South Coast Garage. The plaque of the Cyclists Touring Club (CTC) is prominently displayed between the windows above the shop.

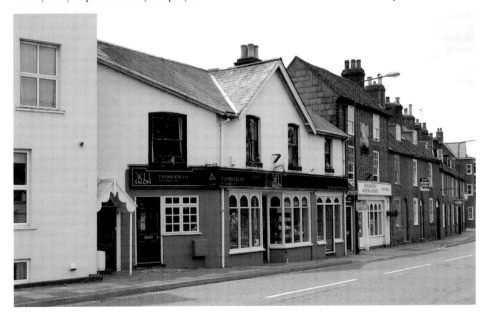

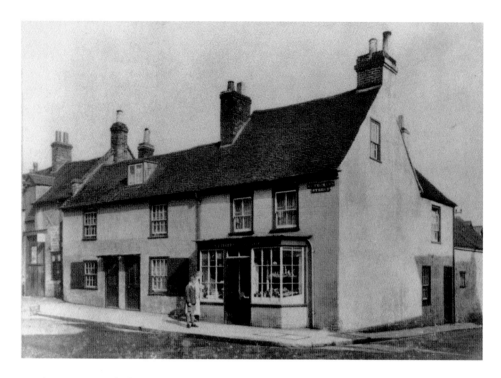

St Thomas Street/Belmore Lane

This corner has seen many changes. What is contrasted here is Hobby's bakery, functioning in the early twentieth century situated in the corner shop, with the modern 'His and Kids' shop located at the base of an uncharacteristic low tower or turret erected about a hundred years later. Architecturally it blends well with the surroundings largely because it retains the scale and the motifs of its neighbours. What immediately preceded it was an unfinished coach garage site, with exposed steel girders, which at this key point was regarded by most people as an eyesore in the townscape.

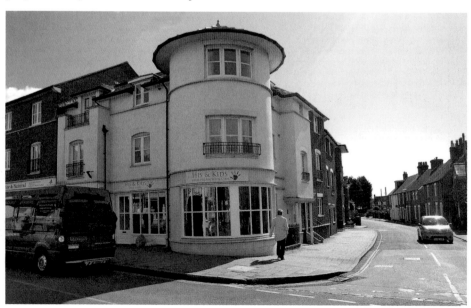

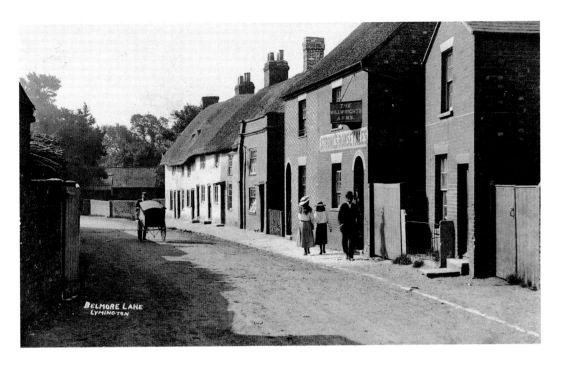

Belmore Lane

This is an ancient route leading from the west end of town to Woodside through what once were the fields of the now defunct Belmore Farm. The old postcard view, looking south, shows the northern end of the lane close to where it runs from St Thomas Street. The short terrace of cottages on the right was destroyed in a fire in 1913 (*see* next page). The Millwrights' Arms pub which closed shortly after the conflagration is also seen on the right. Belmore House, lying to the left of the lane behind the brick wall, was a large town property with grounds extending to more than one and a half acres. The lane has become busy in recent years largely because it leads to the much developed residential areas at Woodside and also gives access to one of the town's largest car parks.

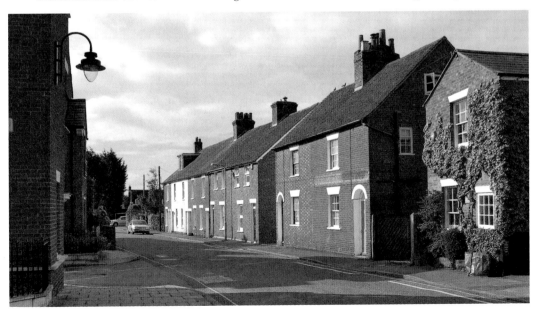

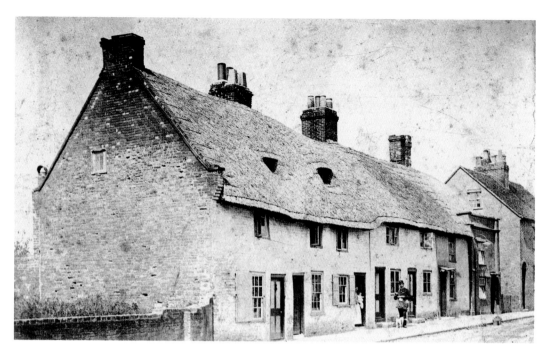

Belmore Lane Cottages

Lymington suffered a number of fires during the nineteenth and twentieth centuries, but only one spread to consume more than an individual property. That was the row of thatched cottages shown above when, in a great conflagration in 1913 the whole terrace was destroyed. Fortunately, there were no injuries or loss of life. Almost as soon as the site was cleared rebuilding took place and a terrace of modern slate-roofed cottages replaced those destroyed. The builder was George Cole of Lymington and his bill for rebuilding the entire terrace survives showing that the cost came to the sum of £750. The building at the far end had been a hostelry called the Millwright's Arms but this escaped the blaze but did not continue life as a pub but as a private house.

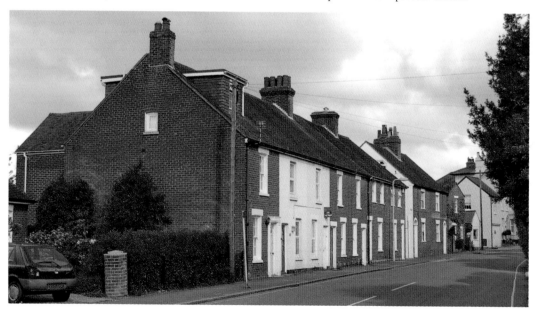

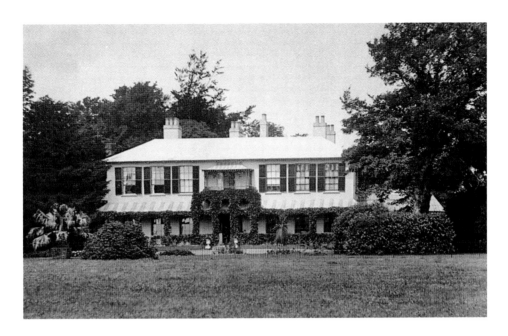

Fairfield House

This was one of the substantial town houses that once stood in Lymington. It was situated in extensive grounds between Belmore and Church Lanes on the agricultural land of Townsend (or Belmore) Farm. The house seems to date from the mid-1820s and its most illustrious owner, who was also the builder, was Ralph Allen Daniel who, during his sojourn of almost a quarter of a century, was to have a considerable impact on the administration and development of Lymington. After passing through the hands of successive owners it fell vacant and for a short period was considered as a candidate for a new town hall but this was not to be and it was eventually sold to a developer who demolished the house and erected an exclusive residential estate of secluded houses each standing in a good sized garden.

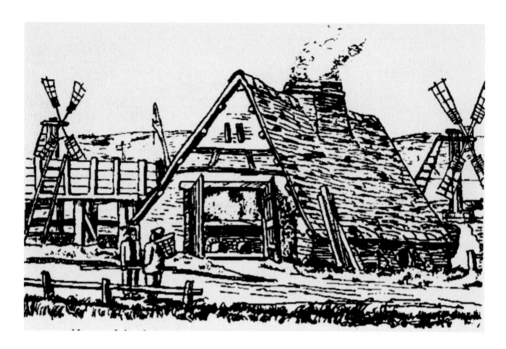

Salterns

Salt making was a major industry recorded from early medieval times until the middle of the nineteenth century. Sea water was collected in shallow ponds and allowed to evaporate until it became rich brine, an operation only possible in the summer months. This brine or liquor, was then pumped into holding tanks from which it was gravity fed into specially built iron pans over furnaces situated in boiling houses where it was completely evaporated leaving the crystalline salt to be scraped off. At one stage, the salt workings extended from Lymington River some two miles along the coast to Keyhaven. The sale of this quality salt produced a large revenue. At Creek Cottage the last remaining boiling house, though shortened and much altered, is preserved.

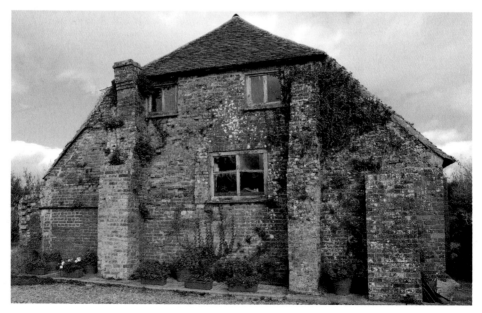

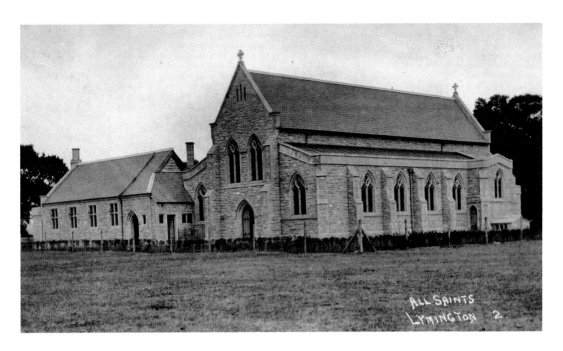

All Saints, Woodside

In 1909 the large Anglican church of All Saints was built at Woodside to serve the population in the southern part of the parish, which had grown considerably in the last quarter of the nineteenth century, particularly around the Waterford roads of Westfield, Stanley, Brook and Spring. Its construction was made possible through the generous bequest of two sisters, Harriet Spike and Fanny Haldane whose premises, Holme Mead, was sold for £4,000 and added to other monies which realised a total of £18,000. The architect was W. H. Romaine-Walker who designed the new church in the then admired Decorated Gothic style. Its first minister was a curate, the Revd Edwin Ernest S. Utterton. All Saints still fulfils its role but now ecumenically shares its space for Sunday worship with the Methodist congregation.

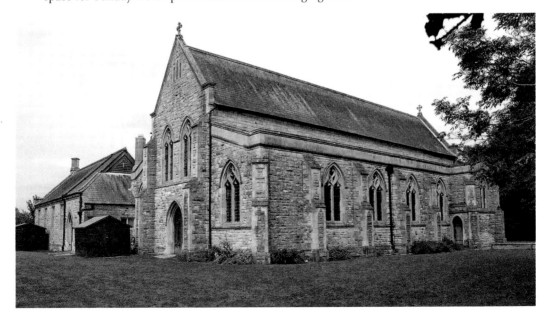

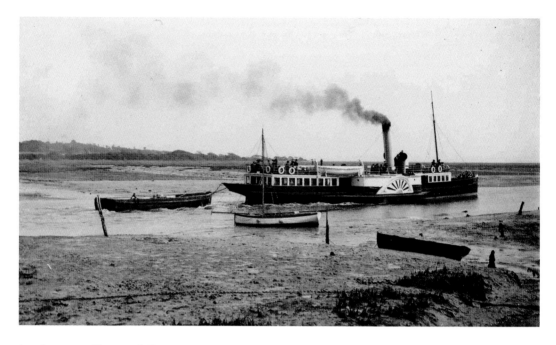

Lymington to Yarmouth Ferry

Steam power ushered in a whole new way of life for the ferry service. No longer were the vessels dependant on the vagaries of the weather and it became possible to institute a reliable time-tabled service. This started in 1830 with the 51-ton, 16-hp *Glasgow* built by Steven Wood of Newcastle. Another innovation made possible was introduction of tow boats, first to carry livestock and carts, and then, in the early twentieth century, motor cars. The old picture shows the PS *Solent* pulling a barge on its crossing towards Yarmouth. At the same spot in 2012 the huge ferry, *Wight Sky*, travels laden with vehicles as well as passengers. Throughout the twentieth century ever larger ferries were introduced and the first of the drive-on, drive-off ferries, the *Lymington*, was commissioned in 1937. It could carry 16 cars and 516 passengers. The present day ferries can carry 65 cars and 360 passengers. Because of their size there was prolonged opposition by many in Lymington against their introduction.

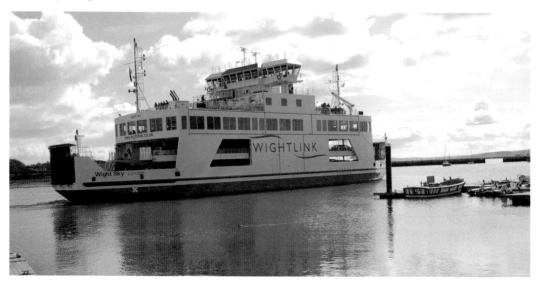

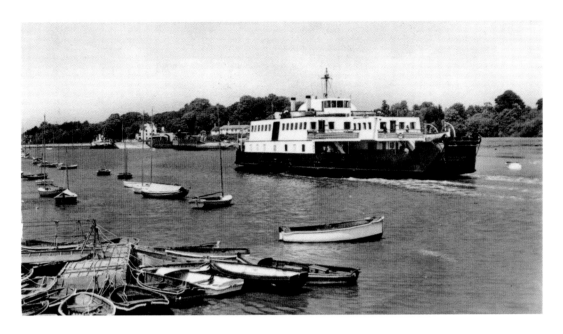

The Isle of Wight Ferry

Ferry boats had run between Lymington and Yarmouth for centuries but with the advent of steam in 1830 they became regular and reliable, departing from Lymington at 9 and 11 a.m., and at 3 and 5 p.m. In 1840 the Solent Steam Packet Co., was able to commission a purpose built ferry named the *Solent*. In 1866 a fine paddler, the *Mayflower*, was introduced and it was this vessel that was used by Marconi in 1897 for his earliest experiments in ship to shore wireless communication. The *Farringford* (above) introduced in 1947, was the second of the new class of large ferries with increased capacity for vehicles. Huge modern ferries, not introduced without considerable disquiet in 2010, now inch their way through the crowded river, contrasting markedly with the situation in the twentieth century.

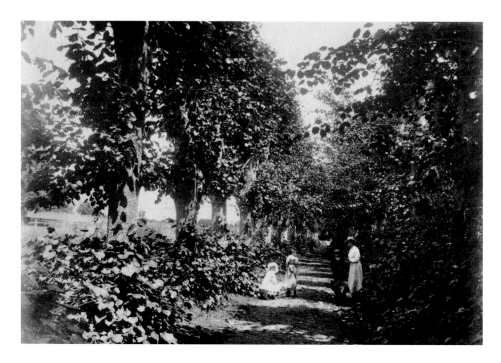

Grove Road

An ancient road which long ago was the extra-mural road along the south wall of the borough was created by William De Redvers, 5th Earl of Devon, in about 1200. Much later it became a ropewalk where the ropes manufactured in the Quay area were brought for final processing prior to being coiled. By the late eighteenth century it had become a secluded road and, probably, about that time the first avenue of trees was planted to provide a delightful and sheltered walk all the more favoured when the field between the Grove and the High Street became a public open space – a quiet retreat from the busy and bustling High Street just a few hundred yards to the north.

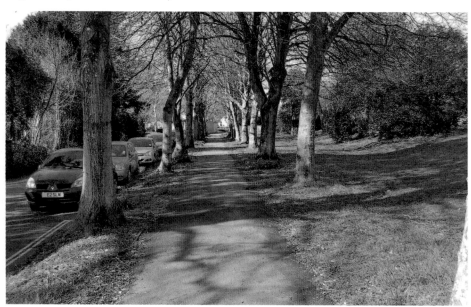

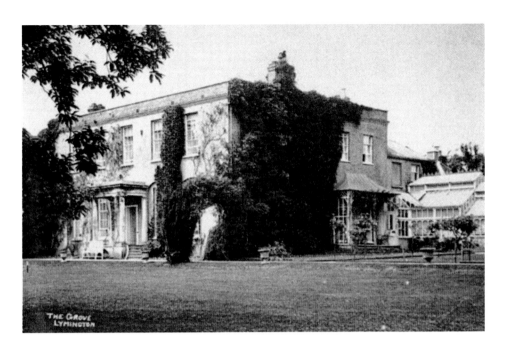

Grove House

This is one of Lymington's mansions built by George Burrard, a member of the leading family in the town and a burgess from 1682. In 1698 he was one of the borough's two MPs. Subsequently, the house was owned by a succession of wealthy and influential families until, in 1944, it was purchased by Dennis Wheatley, the renowned and popular author who wrote many of his best-selling novels whilst living there (*see* page 84). But after twenty-four years' residence he sold the house and grounds and not long afterwards it was acquired by developers who, despite protests, demolished it and transformed the grounds into a large neo-Georgian residential estate.

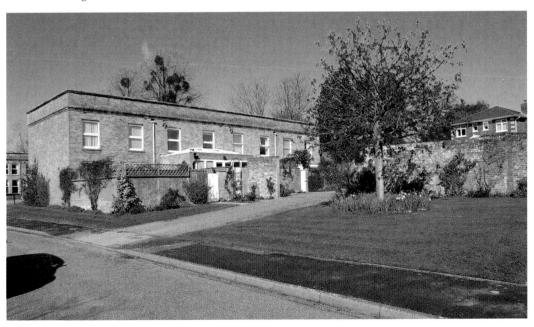

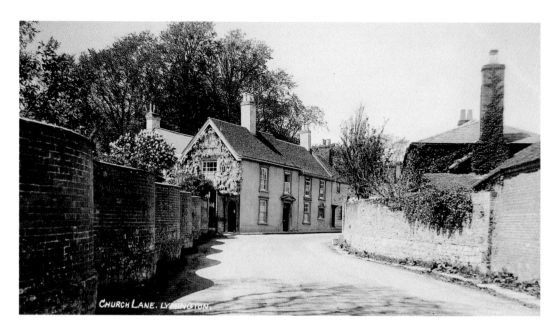

Crinkle-Crankle Walls in Church Lane

These wavy or serpentine walls seem to have originated on the continent and first appear in East Anglia. But Lymington has a number of surviving examples, which have been speculatively attributed to the arrival of the Loyal Emigrant troops from Revolutionary France. The one shown in the old photograph is known to date to the early nineteenth century while the one below, nearly opposite, was built around 1950 by the novelist Dennis Wheatley who, like Winston Churchill, enjoyed brickwork and wrote a book entitled *Saturdays with Bricks* (1961) dedicated to Sir Winston Churchill. He described this wall as 'too wavy', nevertheless, it stands today as a monument to his undoubted skills. The walls derived their strength from the support given by the curves so were relatively economical to construct. They were favoured for growing tender plants, such as peach trees.

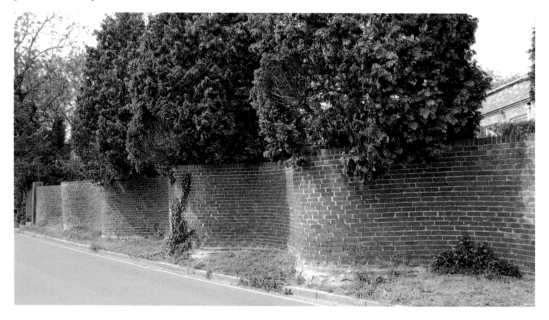

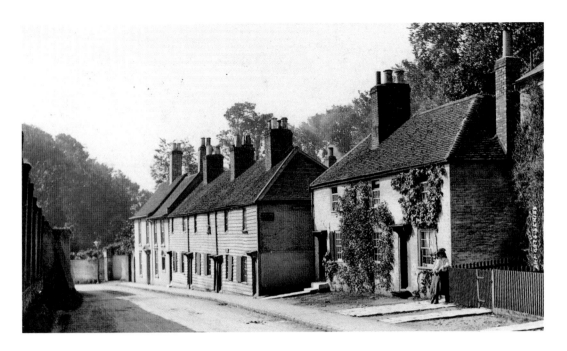

Serampore Place, Church Lane

The row of substantial cottages on the right were collectively known in the nineteenth century as Serampore Place; no doubt after the Bengali town not far from Calcutta (now Kolkata). Although not much changed, it perhaps confirms the strong links that had developed between India and Lymington as many of those who had served in the East India Co. or, later, in the Indian Army or as civilian government officers, had connections to Lymington families or retired to the town on the completion of their service.

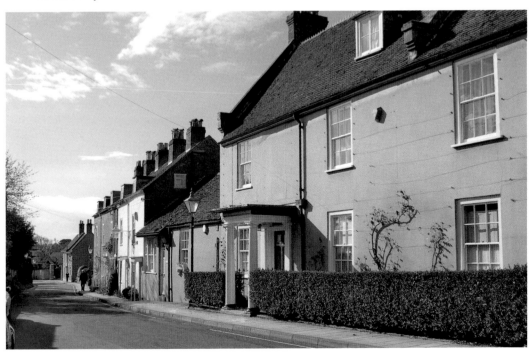

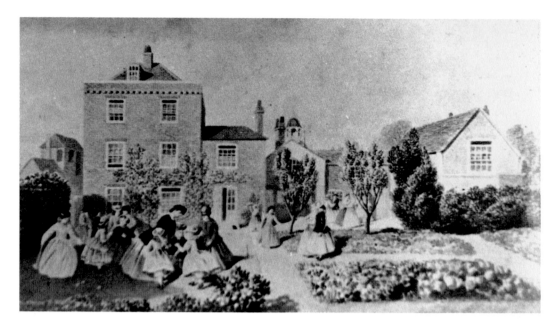

Southend House, Church Lane

During the late eighteenth and throughout the nineteenth centuries Lymington had numerous private boarding schools, many sited in large houses in the High Street. The one above, Southend House, is in Church Lane just a hundred yards from the High Street and, indeed, the cupola of the parish church is visible above the gable in the centre. The school at this time (*c.* 1870) was run by the Perress sisters and, presumably, they are the ladies depicted on the left playing with the children. Southend House is still a dominant Georgian building today, though now a private residence. It has a very fine doorway. The tall building to the extreme left also survives and was used for a long period as a warehouse by the Ford furnishing retailers whose premises were situated at the junction of Church Lane and the High Street (*see* page 7). The brick wall on the right in the modern view is itself very old and encloses one side of the gardens of Southend House.

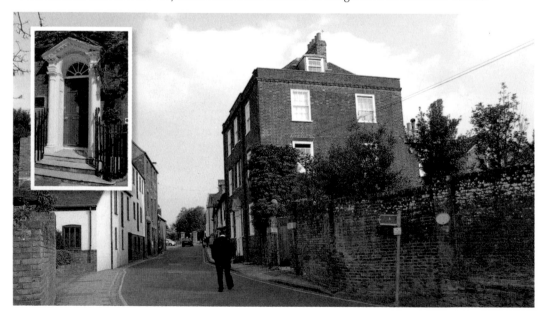

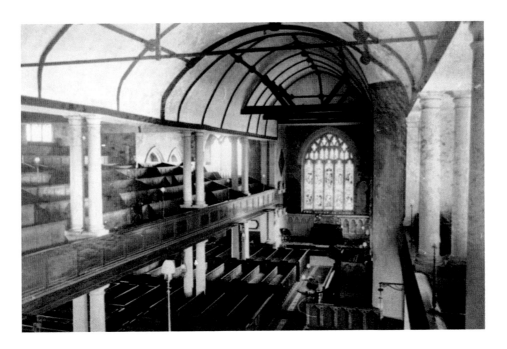

Parish Church of St Thomas; Interior

Like most churches nationwide Lymington's has undergone many changes over the years some only minor modifications while others have been major refurbishments. The last took place in 2011. The old photograph, taken in 1906, shows the wooden box pews on both the ground floor and the gallery, many replacing even older ones removed in the restoration of 1873. Present day seating is provided by more manageable chairs. The roof underwent major structural changes in 1910–11; during these alterations many of the ancient roof bosses were removed and carefully preserved and may now be seen displayed in the narthex. The galleries, built in 1792 with their elegant double columns have been retained and form an attractive architectural feature in the church. One of the characteristics of the most recent restoration is the use of white paint to generally lighten the whole body of the church – nave, chancel, aisles and galleries.

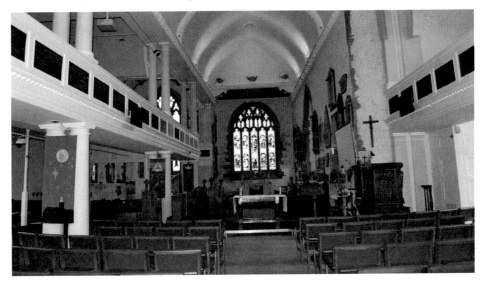

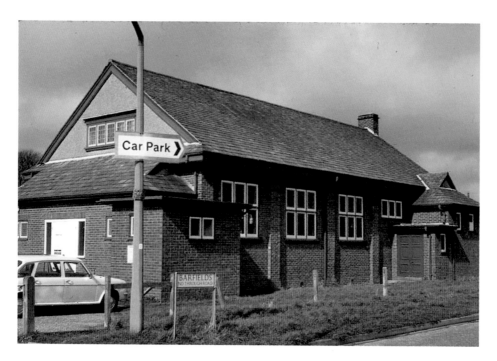

The Parish Hall

This very substantial hall was built to accommodate a range of parish activities and, importantly, to provide a public venue for entertainments, dances and political meetings. It was something both the church and the wider community had lacked, a deficiency not remedied until 1926. The Parish Hall always enjoyed substantial use and was a vital entertainment venue during the Second World War serving the public, the servicemen and women who were stationed in the town and the surrounding areas. But needs change and during the 1970s it was used less frequently, so in 1980 it was sold to developers and a new hall adjoining the church was built with a wider range of facilities (*see* page 5). The old site was then developed as housing and flats and named Parish Court.

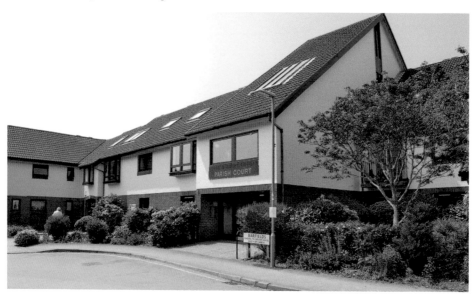

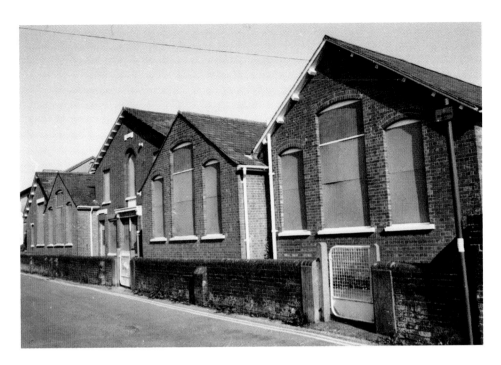

St Barbe School

Lymington's first National School was privately financed by a gift of land in New Lane by Anne St Barbe in 1835. The school was constructed as a brick building with segregated classrooms to accommodate 160 boys and 120 girls but there was a common hall for school assemblies. There were separate entrances for boys and girls. In 1870 the school was extended by adding a projecting wing to either side of the original building and two further wings were added later in the century, thus presenting a front of five gabled ends. In 1840 a carved inscription commemorating the gift of Anne St Barbe was set centrally above a pair of windows and still survives. After serving many generations of Lymington children the school closed in 1991 and after negotiations eventually became the St Barbe Museum and Art Gallery, which officially opened in 1999 and continues to the present time.

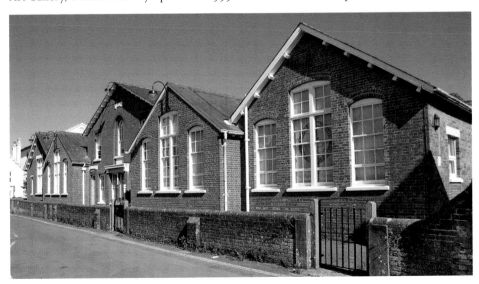

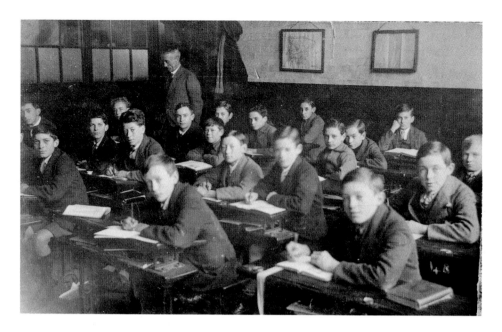

The National School & St Barbe Museum

The land for the first National School was donated by Anne St Barbe in 1835. The school educated many generations of Lymington boys and girls until closed in 1991. After standing empty for a time it was finally leased to the newly formed St Barbe Museum, which has become one of the leading small provincial museums and art galleries in the country with a wide ranging programme of temporary exhibitions. It has a band of active volunteers and, fittingly, still caters for large numbers of children from Lymington and the surrounding areas in a lively and much appreciated hands-on educational programme. It has become a true cultural centre in the town.

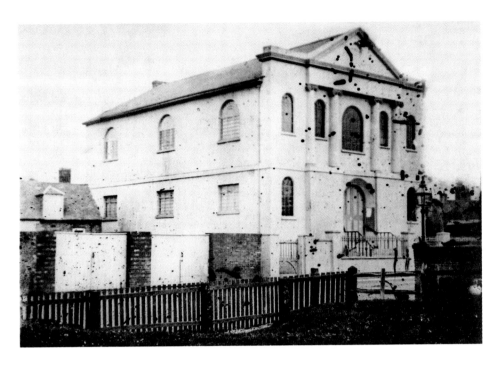

The Baptist Church

The Baptists established a 'church' in Lymington towards the end of the seventeenth century. For worship they first met in a private house. They received widespread support and from 1693 there is a continuous succession of pastors. The church also established chapels in the surrounding parishes of East Boldre, Sway and Milton. The church shown in the photograph was built in 1834 replacing the older meeting house. It incorporated a school and had its own burial ground. The northern side of the church, so well seen in the early photograph is now largely concealed by a later house (Lillington House), purchased by the Baptists in 2005 for £400,000.

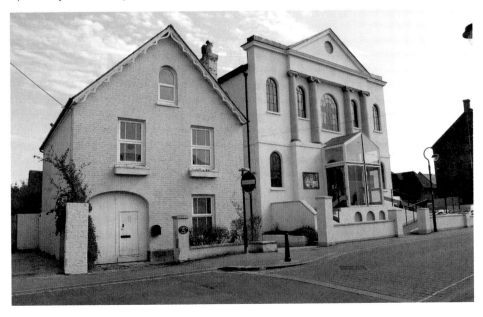

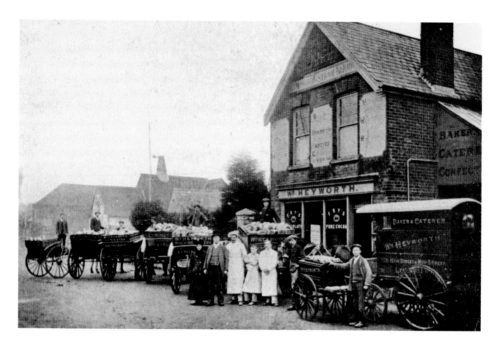

Heyworth Bakery, New Street

This was probably the largest bakery in Lymington at the turn of the twentieth century. The firm also had a retail shop at 119 High Street and another in Station Street. The photograph clearly reveals the large number of staff employed in the enterprise with six horse-drawn carts fully laden with loaves in addition to a hand cart and an enclosed cart. Presumably the three figures in white are bakers and it may be assumed that the man alongside them is William Heyworth, the proprietor, with his wife. However, the impression of a flourishing business may be mistaken as the firm seems to have existed for only about a decade. The main building survives and was subsequently used by a number of commercial enterprises. The building seen behind is a former malt house which today is the actively flourishing Lymington Community Centre, founded in 1946.

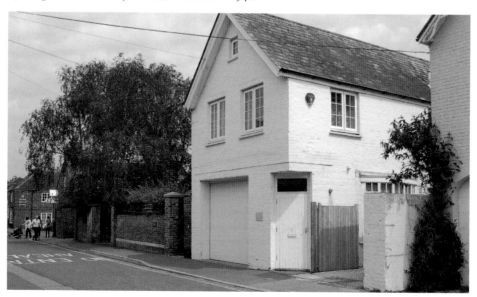

Lymington Community Centre

This building has had a long and varied history starting life as a malt house. At the time of the wars with Revolutionary France it became a barracks for the Loyal Emigrants and, shortly afterwards, the Dutch Artillery. At the conclusion of hostilities with Napoleon in 1814 these premises seem to have been used for disparate purposes and gradually became dilapidated. It was due to the genius of Robert Hole in 1946 that a new and durable role as a community centre was envisaged and brought to fruition. Not only was Robert Hole a great innovator he also inspired others and consequently was able to draw in a wide range of local people to both finance and provide practical work on the project. Lymington Community Centre was one of the earliest in the country and has subsequently enjoyed continuing success in providing for the community at all levels of cultural activity and entertainment. Additionally, it proved an ideal centre for adult education.

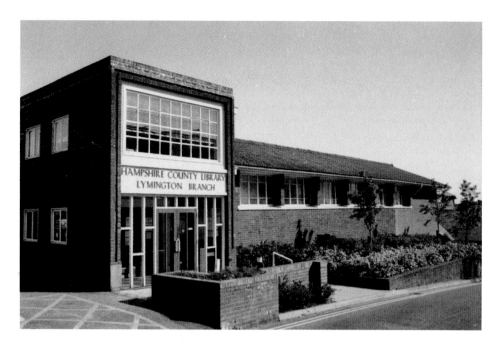

The County Library, Cannon Street

The first Hampshire County Library branch to be opened in Lymington was purpose-built in 1952 to the designs of local architect, Roger Pinckney, at a cost of £6,500. As constructed it was a fine up-to-date building in red brick, but in due course accommodation proved restrictive – even though it was extended twice, once in 1961 and again in 1967. Consequently a new library was built nearby and opened in 2002. The land on which the original library was built had been leased from the Lymington Community Association. It then reverted to this association, through the generosity of two benefactors, Joyce McLellan and Daphne Fuller, and a large double hall was built on the site.

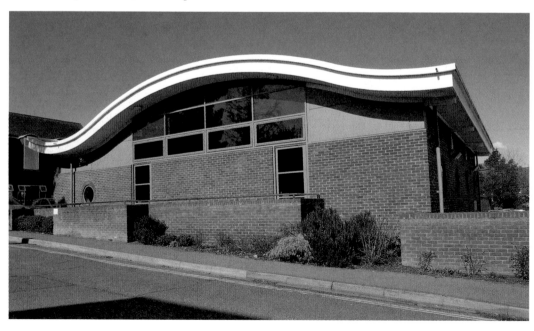

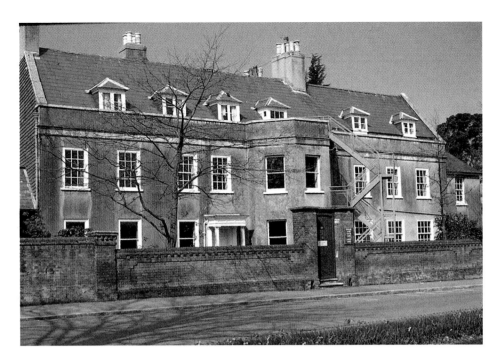

Linden House

This fine early Victorian town house situated in its own grounds in New Street ceased to be a private residence in about 1944 when the property was purchased by Hampshire Association for the Care of the Blind who converted it into a home for the blind. However, as time passed, the house proved unsuitable and was demolished in 1970 to be replaced by a purpose-built residential home, costing £124,000, which was acclaimed for its high standards. Despite local outrage, this home was sold by Hampshire County Council in 2007 and closed and was later demolished after a life of only thirty-five years. The photograph below shows the land cleared awaiting development.

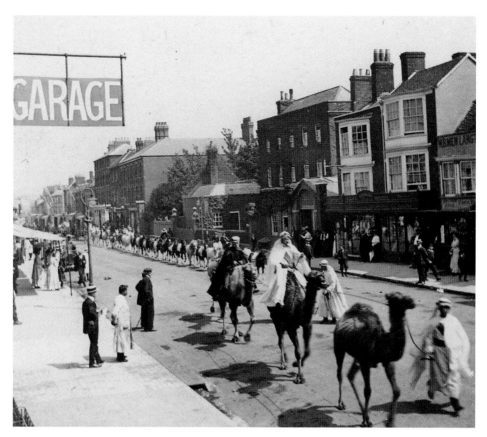

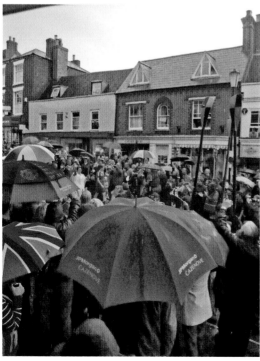

The High Street as a Showplace
Lymington's wide High Street seems always to have played a role as an arena for events, such as elections, parades and carnivals. Importantly, it has hosted the Saturday market almost without a break from the time of Henry III to the present day. The old photograph of about 1920 shows circus animals parading through the High Street as a promotional display for the forthcoming circus. On Saturday 14 July 2012 it provided the route for the public to enjoy the spectacle of the passing of the Olympic torch on its journey to the Isle of Wight via the ferry. It proved to be an event that, despite pouring rain, brought hundreds of spectators on to the street – many sheltered by colourful umbrellas – to cheer the torch bearer on his way.